In Their Mothers' Eyes

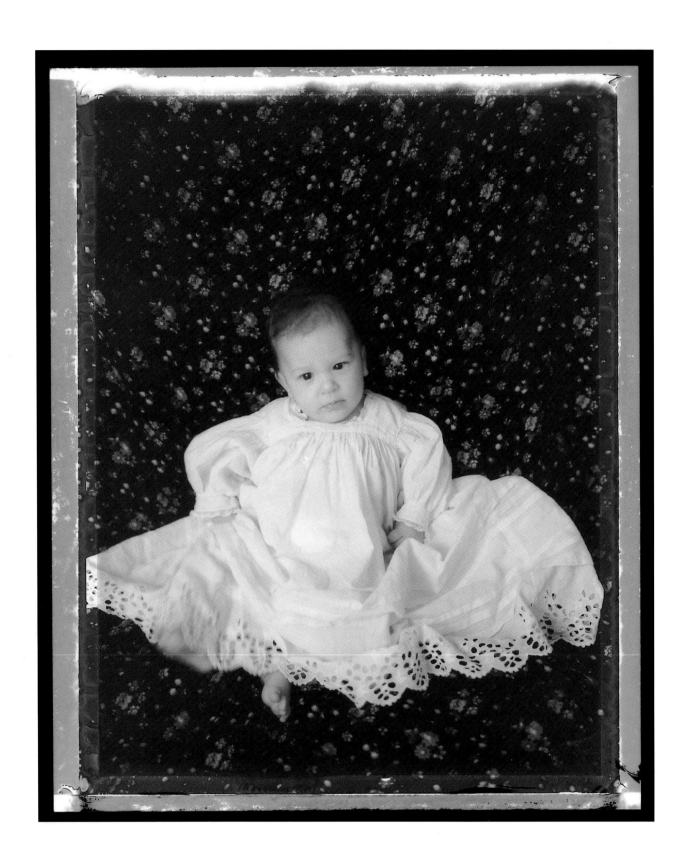

Jill Hartley, Lucinka at 2 Months, **1986**

In Their Mothers' Eyes

Women Photographers and Their Children

Edited by Martina Mettner

Essay by Jayne Anne Phillips
Introduction by Martina Mettner

EDITION STEMMLE

Zurich New York

Contents

In Their Mothers' Eyes

by Jayne Anne Phillips

He was her blood. When she held him he was inside her; always, he was near her, like an atmosphere, in his sleep, in his being. She would not be alone again for many years, even if she wanted to, even if she tried. In her deepest thoughts she would approach him, move around and through him, make room for him . . . the days and nights were fluid, beautiful and discolored; everything in her was available to her, as though she'd become someone else, someone who didn't need to make amends or understand, someone beyond language. She was shattered. Something new would come of her. Moments in which she crossed from consciousness to sleep, from sleep to awareness, there was a lag of an instant in which she couldn't remember her name, and she didn't care. She remembered him.
—from MotherKind *by Jayne Anne Phillips*

It begins in the body. The specific genius of one being unfolds cell by cell. The child begins to move and turn, a miraculous human fish breathing through a cord. Mother and child first speak a wordless language of blood and bone, sharing a pulse as rhythmic and timeless as the seas. The salt bond is strong, a preverbal animal symbiosis as cyclical as the phases of the moon. Menses has prepared and rehearsed us all our lives for gestation, as though the female body endlessly sets its watch, waiting to enter the ultimate human drama. Culture and community have alternately worshipped and demonized women through history, for we are the body personified.

Fear of the body is a denial of mystery, of what is suggested rather than obvious, of all that moves through shadow to fruition. The body, so defined by space and time, is the intricate vessel in which consciousness resides. While the body is time's canvas, blooming in youth, maturing in strength and power, ravaged by age or illness, consciousness ranges unbound. We peruse past, present and future at will, enriched by all the human community has recorded, created, desired, or mourned. Literature, music and art comprise the soul of human consciousness as civilizations rise and fall, often eclipsed by their own failures of self-knowledge.

The dictum of the ancient Greeks, "Know thyself," is a commanding invitation to live consciously, to discern meaning within our own lives and histories and to act on what we understand. The body is the first entry to the self, the sensory apparatus that opens the artist's eye. Early on, women surrender to instruction. The female body would teach us to nurture rather than control, to perceive rather than deny. When we speak of "women's intuition," we refer simply to the expansively honed perception born of acceptance and instruction by the body.

As children we have been our mothers' daughters. We may have wished and planned for our own babies, or been surprised by visitations we elect to receive. Regardless, we are uncertain voyagers the first time out, still innocent of the generative power of our own bodies, unsure how we fit in as animals or angels. Sexuality allows

us the experience of oneness: we momentarily lose our "selves" in the other. Thus the body, in which we are inherently separate, allows us to move beyond the boundaries of physicality and consciousness. When sexual expression results in procreation, the cycle in which we exist enters an approximation of the divine. Women speak of the first sense of life within them as a "quickening," subtle and unmistakable as the twirl of a minnow. The "other" grows within the "self," one within the other. In time, the mother labors, opening by degrees. The child labors, pushing forth.

The body, in every beginning, is the passage to the self.

Pregnancy, birth and the first months of suckling an infant inform a year in which we die to our former selves and become women we could not have imagined: mothers. We take to it or we learn it, realizing that giving birth was a rending, exhilarating beginning: our children separate from us in pain and blood in order to survive and thrive. The child we come to know over years of relationship is present almost immediately in those large, large eyes, immanently herself. We were one; now we are two. The process of raising a child, with or without a loving partner, is endlessly complex. Something can go wrong at any time, and so much can go right. There will be triumph and glory and the sweet mundane bliss of daily life, and there will be problems, perhaps terrible problems, even unimaginable loss. Through it all stands the existence of the miracle: the fact of this child's life and the nurturing of bonds stronger than death.

Art, too, is stronger than death, and lives beyond the body. Children bathed in a loving mother's gaze exist for a time in a protective sheen, the spiritual equivalent of mother's milk. In the past half-century, more mothers have found the passion, determination, perseverance and means to become working artists. We need the embodiment of their perceptions in literature and music, in film and sculpture and photography and performance, in whatever mediums our various cultures may produce. Our children are sacred. We need all of them, and we need the children artist mothers raise. Children who grow up watching their mothers question, disturb, and celebrate the world may learn that men and women do many things and play many roles, and that integration and meaning create a freedom in which more and more of us might realize who we are and why we are here together.

Here, then, in their mothers' eyes, are cherished children, children loved and nourished, perhaps not perfectly, but with passion and hope. Here is the six-month-old already celebrated as herself, the toddler mistress of blanket and bunny, the winged pretender, the avatar. Here is the child body as projection of form and shadow, fine blond hairs lit with sun, and the appraising faces of sons and daughters already glowing with identity. Here is the baby as alchemist and jovial god, commanding all around him or literally crawling through light. Here is the girl child as human mermaid against a shell of luminescence, known to herself as satyr, dreamer, and queen of her own mind. Here are children together, siblings or counterparts, climbing through shadow and silhouette, framed against the world outside themselves. Here are the passages, journeys, and transformations that happen continually in childhood. They grow so fast we can literally see them changing, and they are so beautiful in their own associations, known to one another in bountiful, savage familiarity they will never again experience. Here are boys and girls wearing their gender as one might don a cloak or robe, asking us what we've given them,

what we expect. Always, they are sensual and changeable, touching the world, playing with it. They stare through wands and tread water, natural as lilies, and sleep in their protected beds, dreaming the cosmos anew. They are harlequins or demons or wolves in homemade masks, portraying both innocence and fall. They sail into the future dressed in flowers, veils, football jerseys and their mothers' underwear. They inspire one another to battles and kisses, or appear as spirits floating above lit pools, through baroque hallways. Their faces are classical or they are completely contemporary, frankly observant of their inheritance. The up-close purity and clarity of the youngest seems almost other-worldly or planetary; the facets of their irises, the whorls and lines and planes of their faces, are utterly, astonishingly new.

The lawns and lakes and wet lanes of summer are their natural habitat, for summer is the season of the child. Boys pirouette naturally as dancers above their puddled reflections, or they compose armies of warriors and rearing steeds, bowing to the power of weapons whose correspondence to themselves they have yet to articulate. Summer is the season in which girls race across meadows, ignorant of mirrors, yet already capable of reflecting every gaze through which they pass, chameleons who must retain from childhood the power to possess themselves as women.

Years pass. They grow older and set their toys aside. Their faces are longer and more angular and they peer at us with the same eyes that regarded us moments after their birth. At some point, they photograph us. They tell us to let them go; they tell us to stand behind them as they walk away, drive away, fly away. And we do. We stand still so they can move.

If beauty is in the eye of the beholder, so then is possibility and paradox. If mothers love their children wisely, spaciously, their love becomes atmosphere itself, the air one breathes, internalized as the child roams farther and farther afield, into a future in which the mother inhabits consciousness rather than time. Art remains a message from the nurturer, the truth of what we know, a testament to what we attempt and realize for those who come after us.

In Their Mothers' Eyes presents a spectrum of portraits in which beauty and time coexist. In each there is that moment of "quickening" in which the viewer feels the flutter of a soul. Twenty-three gifted photographers, women and mothers, have wrested art from time by means of love and skill and craft. They redeem moments which no longer exist, and yet exist in transformation. We hold them in our hands. We can look into them again and again as into lakes or pools, seeing more, seeing differently, seeing into ourselves.

Mothers' Gazes, Fixed

by Martina Mettner

"Smell the flowers," my mother would say as she directed me to pose for a photograph. She loved flowers, and she loved me, so both of us had to be in the picture whenever the opportunity arose. And there were plenty of opportunities, especially in the spring. We took frequent trips to Holland at that time of year. The Dutch have huge tulip fields. Red, yellow, and pink ones. Really beautiful. "Just stand next to them!" I soon grew taller and towered above the top edges of the splendidly colored flower beds in the public parks and the huge garden centers, but nothing changed. At first, it was enough to bend my head down toward the blossoms. But by the time I reached puberty, if not sooner, I had no choice but to crouch at the fringes of those fields of flowers. That took some artistic effort. My face was supposed to be framed by the blossoms, so that as many of the precious floral treasures as possible could be seen in the picture. But my feet had to stay firmly planted on the path during this balancing act, lest some gardener complain. Convinced I could never match the beauty of a tulip, I gazed sourly at the brightly colored blooming splendor and resolved henceforth never to be humble in the presence of plants again.

That may explain why I tend to approach postcard stands with caution, and avoid stationery shops and gift-book displays in store windows today. The ubiquitous Anne Geddes with her baby faces in flower blossoms still brings tears to my eyes. Coolly calculated, the kid/garden combination could have made us rich, as well.

From Cliché to Art

Yet cool calculation is hardly involved when mothers photograph their own children. Reaching for the camera is a purely emotional gesture. And unfortunately, most photos in albums look that way, too—well-intentioned but banal and meaningless to anyone outside the family. And there is always too much brightly-colored extra baggage in these photos. Compared to them, the stiff but uncluttered images of earlier children's photographs are a visual breath of fresh air.

In a photo series devoted to her daughter (pp. 21–25), *Jill Hartley* shows how one can play with clichés in a humorous and artistically convincing way. In the style of the standardized studio photos of the nineteenth century, Lucina poses with such personal items as her favorite security blanket named Kiki. Jill Hartley actually took these unusual photographs for her own family album. They are published here for the first time.

One's Own Child in Focus

It should come as no great surprise that women artists or mothers with a professional background in photography are able to take photographs of their own children that no one (except them) would think of hiding away in a personal photo album. Once taking photos has become second nature, it is only natural for the photographer to focus her camera on her own child or children. After all, they are under her feet most of the time.

A case in point is photographer *Esther Haase*, who took the pages of major magazines by storm with photographs bubbling with joie-de-vivre. Her daughter Marlene, born in 1994, dances across a meadow in a sweater much too large for her, while models and stylists go about their work outside the frame of the picture (pp. 77–79).

Mothers Watching

Of course, a mother's attention is directed first and foremost to her child's well-being. And no mother takes photographs all the time. Yet because she has learned to see, a photographer responds to visual stimulation and reaches for the camera when, for example, the light falls on her child in a particularly appealing way. And that is why we, as viewers, take pleasure in photos that address the theme of childhood in a number of very different ways—photos that emerge from this touching mélange of love, trust, affection, and artistic skill.

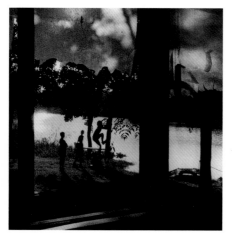

Debbie Fleming Caffery, May Van's Camp, 1987

The picture that epitomizes this watchful mother's gaze for me, one I first saw some ten years ago, is a photograph by *Debbie Fleming Caffery* published in her book entitled *Carry Me Home*, which features black-and-white images of the Louisiana Sugar Country: "May Van's Camp" (p. 53). The mother watches attentively—the children are climbing a tree, and what is more, the tree stands on the shore of a lake. She has assumed the role of the ever-vigilant guardian angel but realizes at the same time the enormous visual power of this almost tropical scene. Thanks not least to the lizard seen in the upper part of the photograph, Debbie Fleming Caffery succeeds masterfully in playing out her fine sense of visual composition: with layered pictorial planes receding from foreground to background, a graphic spatial structure, a dynamic diagonal through the children's movements, and a distribution of dark and light areas that creates an aura of suspense.

A similar need to know what the children are up to might have produced the picture of the two diaper-clad toddlers at the screen door to the veranda (p. 55). Ruth, the smaller of the two children, is trying to find out whether her index finger will fit through the screen, while her older brother, who has hold of the door, appears distracted by something outside the picture. This photograph derives its artistic quality and its visual appeal from the convincing presentation of children at play and from the symbolic content it communicates, at least subliminally, to the viewer: The mother—we must remember that she is also the photographer—is inside the house. Though still within her sphere of control, the little girl is already on the verge of escaping from the mother-child symbiosis; her older brother still clings to the familiar, but has clearly crossed the threshold to the world outside.

Fine examples of the watchful mother's gaze that still falls even on teenage children are found in the portraits of Lyerly (pp. 129–131). "We had a swimming pool in our backyard when Lyerly was growing up," writes *Sarah Benham*. "She and her friends spent their summers there under my watchful eyes. I had begun taking photographs and was longing to travel to unusual places when suddenly I realized that I had the most wonder-

ful subject matter right at hand." She views the portraits of Lyerly as a never-ending project, and now photographs not only her daughter but her daughter's children as well.

The Motif, Child's Play

Even among women photographers, the impulse to photograph one's own children is "sometimes the same as that of the mother who is making a casual snapshot," as *Nancy Marshall* points out,—except that she uses a view camera and makes prints using a high-quality platinum or palladium process. In this respect she doesn't distinguish between photographing her kids on the one hand, and her own particular specialty of landscape photography on the other. Thus it seems only logical that her two small children appear as figures in a landscape (pp. 102, 103). The frame of view becomes smaller as Katherine and Patrick grow older, as if the mother were seeking assurance that they are still close by (pp. 104–106). She simply enjoyed photographing her children, as she explains, but there was never any kind of system involved. Nancy Marshall herself was actually astonished when she realized how many pictures of her children she had accumulated over the years—evidently a family treasure that remains to be recovered.

Lucia Radochonska's treasure is the series entitled "Through Carole" which has been exhibited and published internationally. Whether at home in Retienne, Belgium, on vacation in the French Lot region, or in the Boboli Gardens in Florence, she was always on the scene with her camera whenever Carole danced and played in a meadow. Memories of her own childhood days in Poland, recollections of the feel of grass, water, and wind on her skin played an important part in the images she created. The French-speaking photographer is also concerned in her other projects with nature themes and the world of childhood as pictorial motifs. In the series on her daughter, she succeeded in creating an ideal link between the two: as if a cherub had escaped from a baroque church and taken refuge in nature, free to enjoy being alive at last (pp. 27–29).

The idea of capturing something of the innocence of childhood in the picture, and thus preserving it in memory, is the underlying motivation behind the impulse that prompts a mother to reach for her snapshot camera and the photographer to pick up the tool of her profession or her art.

Awareness of the transcience of childhood and the fragility of family ties led *Margaret Sartor* to photograph her immediate family and her hometown in Louisiana. Since becoming a mother herself, she naturally photographs her own children as well (pp. 121–127). "And I have found," she says, "more often than not, that making photographs brings me face-to-face, not only with the beauty I cherish but with the ragged and tender human vulnerability I fear."

Deborah Willis wages war against fading memory at several different levels. Her efforts to document her own family's history and her photographs of her son at play are but one of these (pp. 73–75). As a photo-historian and curator, she has devoted herself for more than twenty years to research and rediscovery of the rich heritage of African-American photography.

A New Color

Documentary photographer *Mary Motley Kalergis*, who investigates the lives of strangers with her camera, found it impossible to continue working in her accustomed way after the birth of her second son. And because she could no longer travel, she turned her camera on those closest to her—her children, "who were simultaneously keeping me from my creative work while inspiring me to dig deeper and take new risks." Asked why she photographed her babies against a black background—a highly unusual approach—the mother of four responded: "I realize that all that black space might be symbolic in the sense of the isolation that a young mother might feel when she's home alone with the twenty-four seven responsibility of infant care" (pp. 113–115).

In her own photography, *Flor Garduño* sees black as space for imagination: "You really have to look into the picture." Her children's photos are also characterized by a sometimes dark but always dreamy, almost unreal beauty (pp. 97–99). "I was born in Mexico City," she explains, "but I spent my childhood in the country. So all these pictures, even although I may no longer have them before my eyes, are still at the back of my mind." Since her marriage in 1989 the Mexican photographer has also lived in Switzerland, but the signs and symbols of Indian culture continue to play a leading role in her work. In primitive cultures, she explains, "every person guards his own personal symbols. I create semantic imagery."

After *Maude Schuyler Clay* returned from New York to her homeland in the South and brought her first daughter into the world, she began doing color portraits. Since she spent most of her time with her children, it was quite natural for her to photograph Anna, her son Schuyler, or Sophie (pp. 59–65) whenever the light seemed right. During the same period, she worked on a black-and-white portrait of the Mississippi landscape to which she remains so closely bound today. Her book *Delta Land* was published in 1999. Even as a mother of three, she found time to work on two major, though regional, photo projects at the same time.

From Child to Camera

Photography or, to be more precise, the practice of taking photographs as a serious pastime pursued with passion, is a family-friendly way, so to speak, of establishing one's individual identity as a woman apart from an existence as a full-time mother for whom children are all there is to life. Indeed, the creative process itself, at least in a technical sense, is very short. Expressed somewhat differently: Anyone with a trained eye could theoretically produce a good photograph in, let's say, a half-hour of concentrated photographic work. But try focusing productively on the fictional world of your novel when you know you've got to start cooking dinner in thirty minutes! Despite Joanne Rowling's success with *Harry Potter*, the fact remains that photography is definitely preferable to writing when it comes to mother-and-child logistics!

One of the unique qualities of photography, apart from its ready availability, is the diversity of purposes it can serve—from personal use for the preservation of memories to commercial application in magazines and advertising, from documentary (reportage and travel features, for example) to art photography. Another essential characteristic is the division of the process into image-taking and image-processing. Creative—if not outright

artistic—photography involves two different acts of selection: the first just before the shutter clicks and the second during the process of selecting (and printing) the image. What sets the amateur photographer apart from the professional is that he does not make this second selection. In his eyes, every picture is equally important. The commercial photographer delegates (usually by necessity) the task of making the second selection to ad agency art directors or magazine editors. Only the independent art photographer takes control of the entire process.

Thus there are reasons enough to explain why photography is so well suited as a medium of expression for mothers: children or domestic life per se can serve as objects of the expressive urge. The mother even remains accessible to the children during the (first part of the) creative process. Her presence and attention give the children a sense of security, and specific parts of the process can be delegated to others or completed when the children are asleep, or out of the house.

Thus is it no wonder that some of the women represented in this book did not discover their talents as photographers until they became mothers.

Images in Sleep

Sheila Metzner had already acquired a trained eye for image selection when she gave up a promising career as an art director in an ad agency after the birth of her first son Raven. A friend suggested she take up photography. "You live like an artist. You have a good eye, you'd be good at it." She has long enjoyed international recognition for her fine art color photographs (pp. 31–35) as well as her commercial work.

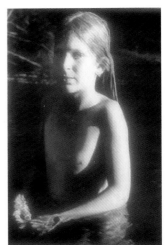

Sheila Metzner, Evyan, **1975**

It may sound incredible, but she has raised seven children: Raven, Bega, Ruby, Stella and Louie, along with two daughters from her husband's first marriage, Evyan and Alison. "When they were really small, I'd be with them during the day photographing and printing at night. At eight or nine in the evening, when they were all asleep, I'd take a shower to wake up and put on high heels and lipstick, which I wore then, to give me the feeling of being ready to work." And after nine years, *Sheila Metzner* had accumulated twenty-two photographs she was truly proud of. One of these was chosen by John Szarkowski for the influential touring exhibition *Mirrors and Windows* of 1978. Sheila Metzner's photo of Evyan was the dark-horse hit of the exhibition. She held her first solo exhibition that same year at the Daniel Wolf Gallery in New York.

Sheila Metzner's photographs of children do not differ in terms of elegance and style from her other works. Her children's portraits are presented along with her famous still lifes as *Objects of Desire* in her first monograph, published in 1986. And Sheila Metzner frankly admits that she tends to turn people into objects. And since it is hard to imagine a living being that can look so much like a still life as a sleeping child, she chose this as one of her first motifs. And here it is again, this watchful mother's gaze. Is he breathing? Is she sleeping peacefully? Is my baby really all right without me? The door to the child's bedroom is open, and in the weak light it crystalizes, this image of the

child, guarded in sleep by the motionless cat or by mute playmates—an image the mother can now contemplate in peace. And of course the child, at its most vulnerable in sleep, is a particularly touching sight. This is the perfect moment to preserve the thought and the image in a photograph.

Annelies Štrba gave in to this impulse (pp. 37, 39). Her initially hesitant approach to children as motif and to her own abilities as an artist appears to have set a great many things in motion. "What progress she has made between her first exhibition in 1990 at the Kunsthalle Zürich and the extensive show that presently fills the entire Kunsthaus Zug," wrote Caroline Kesser on April 29, 2001 in the culture section of the *Neue Zürcher Zeitung*. "Not a trace is left of the housewife and mother who, mostly by the way and often secretly, took the liberty of photographing her children in bed, in the bath, or in the kitchen. Here is an author who has grown self-assured, almost expansive in scope, and who has gained mastery of all the techniques required for her purpose." Today, she works exclusively with a video camera, and the photographs she selects are wall-sized. Still, however, "her work" emerges from "the midst of her life and is indebted only to intuition."

The photographic art of *Verena von Gagern* also bears the imprint of her efforts to come to terms with her life. And though photography remains an important medium of expression for her, it is no longer the only one she uses. "My four children have accompanied me through very different phases of photography," says the artist and architect. "Rather more so than the reverse—if I could really have accompanied the children with photography."

Changing Roles

Special momentary effects of light (and corresponding shadows) play an important role in the work of Verena von Gagern (pp. 41–45). It was a photograph of her first baby that prompted her to take up photography, and it is symbolic in a number of ways, for she soon earned acclaim with her photographs of children, and Franziska, the infant in the early picture, is now a photographer herself.

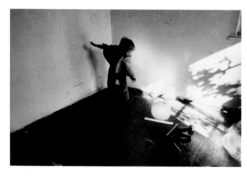

Verena von Gagern, Moritz with a Ball, **1976**

Following the birth of her first child, Verena von Gagern received her degree in architecture at Pennsylvania State University. There she attended a photography course, more by coincidence than by plan, and was introduced to photography as a medium of expression—a rather unusual approach for a European. "I remember one picture among all of the many photos I took that caught my attention. It was a detail of the baby's body in a very special light. And that was the first photograph that struck me as more photographic than anything else." She goes on to explain her conversion to photography: "Then I had my second child and put all of the energy I could muster against a woman's fate into photography." Here, we clearly see photography identified as a tool used in coping with the role problems associated with motherhood—avoiding total self-abandonment for the sake of the family, establishing an identity independent of the children through creative activity.

In 1975, Verena von Gagern summoned the courage to present a portfolio of her family photographs at the Rencontres International de la Photographie, a major photo festival in Arles in southern France. She was awarded the Young Photographer's Prize—and shortly thereafter received offers for exhibitions in well known galleries in several different European countries. "And that," she remembers with a touch of disbelief after all these years, "with these children's pictures, which I never regarded as children's photographs." She sees them as "existential images in which the kids were present . . . like people. . . . Well, I have always protested when people referred to me as 'the one who does children's pictures.'"

Undoubtedly, this distanced stance was largely attributable at the time to the influence of the women's movement. In the late seventies and early eighties, young women, especially those with college educations, were expected to pursue a career and achieve personal fulfillment—instead of marrying young and devoting themselves to the care of their children. Verena von Gagern deliberately accepted the role of wife and mother, but she was also "restless and eager to work." By making her personal life the focus of her urge for expression, she was able to unite the two, family life and photography.

Graciela Iturbide was already a mother of three when she took up photography in 1969. Barely twelve years later, she was selected as one of six Mexican photographers shown at the exhibition *Photography in Latin America from 1860 to the Present*, the famous show organized by Erika Billeter at the Kunsthaus Zürich. Although she had gained recognition as a reportage photographer, she also made touching portraits of her two sons in the classical style (pp. 117–119). The boys look deeply immersed in themselves, as if the pain caused by the loss of their sister were apparent in their posture and their eyes.

Britta Holzapfl "always keeps a role of film in her apron" in order to be prepared whenever the opportunity for a portrait arises. A photographer with two doctoral degrees and three children, she has developed a very personal style characterized by traces of pictorialist influence (pp. 81–85). She photographs children only—usually her own, but sometimes their friends as well. Born in the late fifties, she studied medicine as well as German Language and Literature and seemed to be on a fast track to a splendid career. Yet she (like others) refused to meet the expectations people had for her, choosing instead to marry and, while raising her children, devote herself to photography, her long-standing passion.

Controversy and Conflict

In her exhibition catalogue *Still Time*, published in 1988, *Sally Mann* wrote "I struggle with enormous discrepancies: between the reality of motherhood and the image of it, between the love for my home and the need to travel, between the varied and seductive paths of the heart."

Sally Mann had earned recognition as a photographer before she became a mother, but from the mid-eighties she photographed the life of her children in an idyllic setting at their home in Virginia (pp. 47–51). The black-and-white photos were published in a book entitled *Immediate Family* in 1992, and triggered quite heated controversy.

Privacy and Publicity

It is perfectly normal for the personal and the fictional to intermingle in the work of visual artists and writers. After all, writing is always based upon experience, which the author turns into fiction. The outcome needn't be true but should at least be probable. The photographs in this book also contain elements of truth—that which they depict. But what we think we see in them is only probable, at best. Photographs are minute details, overstatements; images of a moment that merely permit us to assume that we are learning something about the private lives of the people who appear in them. "Some are fictions," says Sally Mann quite rightly with respect to the pictures of her children, "and some are fantastic."

The idea of making one's own life the object of artistic expression would occur only to someone who is open-minded, unconventional, and liberal, someone who has no need to suppress anything or to create taboos—and someone who also has a suitable biographical background.

The discovery of significant parallels in the lives of two artists who have explicitly designated their private lives as the motifs of their art—Sally Mann and Verena von Gagern—is as stupendous as it is plausible. Both women come from doctor's families and show the influence of the liberal to unconventional attitudes frequently encountered among medical practitioners. As children, each spent a great deal of time alone with her childhood fantasies and games. Sally Mann describes her father, a country doctor, as a taciturn, creative man of unconventional ideas, as one who saw no contradiction between moralism and atheism. In Verena von Gagern's case, both father and mother worked as physicians. Her mother also had three children. To say the least, her dual career as a practicing physician and mother was unusual during the post-war years.

Using one's own children as a motif also demands a strong personality—an exceedingly strong one, in fact. It is difficult enough to bear public criticism of one's work as it is, since every form of artistic expression is always highly personal. Yet how much harder must it be to find oneself exposed because of one's art to public criticism as a mother.

Having presented her children in the nude in *Immediate Family*, Sally Mann unexpectedly achieved a degree of popularity she presumably could have done without, for as David Levi Strauss remarked in an article in *Artforum* in 1998, "The appearance of her pictures of innocence and experience happened to coincide with a full-blown national sex panic, driven by right-wing moralizing and societal confusions about children and sexuality."

The Absence of Fathers

Until just a few years ago, people might have attempted to explain the obvious absence of fathers from these pictures by arguing that they are rarely found in the domestic (and thus female) sphere. Yet when fathers are regarded with suspicion simply because their own daughters sit on their laps, their absence from family photos becomes all the more understandable at the very places and points of time at which many of the photographs in this book were taken: on hot summer days, at the waterside, when children could be running around naked or sparingly dressed. The immediate family is noticeably incomplete.

Niki Berg's husband also remains out of the picture: "I began to photograph what I knew best, my family, starting with my grandmother and then my mother, myself, and Karina." Some of the portraits she made of her daughter are in black-and-white, others in color (pp. 91–95). While Niki Berg's photography reveals the influence of the straightforward classical portrait art of an August Sander or a Mike Disfarmer and the sculptures of the Danish artist Gustav Vigeland, her primary objective in using color is "to add a layer of sensuality to the image," in order to communicate a particular mood or feeling.

Looking at most of the photographs in this anthology, one has to remind oneself that these photos of children document not only specific moments in the lives of the children, but also the presence of their mothers as well as small segments of their mothers' lives. That is not so in the photographs of *Tina Barney*. With a cool, slightly mocking gaze and a large-format camera, she has worked among the rich and by no means universally beautiful people in her circle of friends and acquaintances for many years. Putting the crowning touch on Tina Barney's *Family Album*, she enters the picture personally, presenting herself in vivid "Technicolor" alongside her grown-up sons (pp. 133, 135).

In much the same way that Tina Barney records the life of the upper class on the US West Coast, *Patricia D. Richards* shows "what life was like in a southern American suburb at the turn of the twenty-first century and beyond" in her *Scenes from Early Morn Drive* (pp. 67–71). Her house is one of two hundred and fifty identical structures. At least it was when she moved here in 1979. It must have been a shock to her, for, raised in Seattle, Washington, she had spent the last ten years with her husband in Europe—and now he had taken a job in Plano, Texas!

The scenes in Patricia D. Richard's photographs look like film stills. They are not staged, however, but simply reflect the fact that she is always with her children and that they all treat one another with respect—the more so, since her husband left the family. In the photo of the kissing teenagers (p. 70), the daughter appeals to her mother to put a stop to their necking. Here, the mother's presence is addressed indirectly in the photo.

That is also the case in *Donna Ferrato's* "Fanny fed up with Mama" (p. 139). "Well, she'd had enough of me being in her face with the camera," explains the reportage photographer, who refers to herself as a "parsimonious picture taker." But she is always on the alert "when the emotion from people's hearts and minds gets to the explosive stage." "Funnily enough," she says, "Fanny likes that photograph."

Donna Ferrato received the prestigious W. Eugene Smith Award in 1985 and photographed herself on that happy occasion with her own family (p. 137). She never actually married Fanny's father, Magnum photographer Philip Jones Griffiths, however, and given her long-standing commitment to the fight against domestic violence, a change in her attitude toward the institution of marriage appears unlikely. The presumed living room is a room at the Hotel Esmeralda Hotel in Paris. With her self-portrait, Donna Ferrato presents a mirror more to us than to herself, for what takes shape in the viewer's imagination is not her life at all. Thus it is with photography. It depicts something but proves nothing. And this particular photo is the only one in the book featuring a complete small family.

Doing It All at Once

The fact that the specific process involved in photography makes it the ideal expressive medium for mothers does not mean, of course, that women photographers needn't grapple with the age-old conflict between mothers' concerns and children's demands. Yet professionally active mothers always seem to be just a little more efficient than other people. And that certainly applies as well to all of the women photographers represented in this book. But Patricia D. Richards, a mother of three, has come up with a particularly original solution.

With one son aged thirteen and her youngest only four, it seemed to her that she was spending virtually all of her time with at least one child in the car. And for many years she had no darkroom of her own. But, as she recalls, "The sun and the history of the medium I craved solved my problems." Patricia D. Richards uses a large-format camera, an old 8 x 10 Korona. Considering the size of the negative, it occurred to her that she could make prints of her photos in the car! While driving! "Printing in my car was an absolute fantastic discovery, because it allowed me to do the two things I most desired: make photographs into prints and carry on as the Mom."

Well, every working mother might point out that multitasking is her middle name. But how many would have hit upon the idea of picking up the children from school and printing photographs at the same time? Or shopping at the supermarket while doing darkroom work? It is at any rate more original than ironing in front of the TV! Like the pioneers of photography, Patricia D. Richards used printing-out paper, which reacts to the ultraviolet light that is abundant in the treeless state of Texas. So her car was always full of contact print frames. "With the ones on my dashboard or on the front seat, I could use the time at stoplights to check their progress

by bending down and opening the hinged back in the shadow under the dashboard. Other cars were constantly honking at me, as I happily checked my prints. The kids would often holler from the back of the car that they thought one of my prints was 'done.' Then they'd turn the printing frame face down so the light no longer hit it, and get on with whatever else they were doing at the time. It was an especially funny season when I drove carpool for the 8th grade boys' football team. As they piled into the back of my station wagon they'd carefully turn the printing frames face down and put them in a corner of the car in order not to sit on them! Printing had become a community event, born out of the necessity and desire to make pictures."

Patricia D. Richards, Barbie's Portrait Studio, **1992**

The Brief Ten Years

The years of intense mother-child intimacy are brief and precious. *Sandi Fellman* published images from this period in *Baby*, an entire volume of photographs featuring sensitive nude studies of parents and children: sensual moments captured in the protected atmosphere of a photo studio. An equally tender and striking father-and-child gesture is seen in the photographs of her son Zander in his father's arms (pp. 109, 111).

The fragility of these early years is expressed in *Joyce Tenneson's* photos, portraits of her son Alex between age five and ten that exhibit strikingly subdued tonal and graphic effects (pp. 87–89). "Photographing my son," the photographer notes, "was like opening a window on an exotic and mysterious world and his outer and inner radiance at times left me breathless."

As children develop into self-reliant little people, they tend to be photographed less often. That is no different for photographers than for other mothers. The exceptions, which reflect artistic concepts in the case of Barney and Richards, for example, only serve to prove the rule. And, of course, all these mothers respect their children's privacy. Ten seems to be the threshold age. Thus we find at the end of Sally Mann's *Immediate Family* a photo of her son standing in the water. The caption below reads: "The Last Time Emmett Modeled Nude, 1987." Joyce Tenneson recalls that "When he was about ten years old, Alex told me he didn't like being photographed anymore. He was entering a phase of his own personal journey where there was a need for privacy." And speaking of her daughter, Niki Berg says that "Karina loved being photographed, at the same time she felt increasingly ambivalent as puberty approached."

The more independent the children become, the easier it is for women to focus on their own personal interests. As Verena von Gagern recalls, "At some point, when they began to move away from me as they approached the age of ten, I just stopped photographing them, without thinking much about it at all." Women photographers turn their attention to things outside the house, or pursue their commercial careers with renewed intensity. Shifting her focus from the children, Sally Mann began photographing the quiet landscape of the American South. She entitled the project *Mother Land*. How fitting.

Jill Hartley

"Originally, I thought I'd make portraits of my daughter at regular intervals on polaroid positive/negative film. Eventually, I made them when Lucina was willing to pose. Because of the slow film speed, she needed to be very still. Thus the project became a collaboration between the two of us."

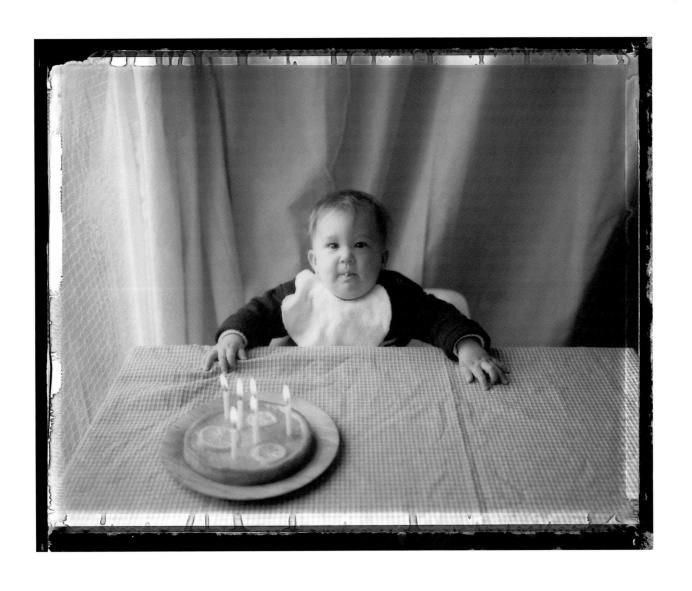

6-Month Birthday Cake, **1987**

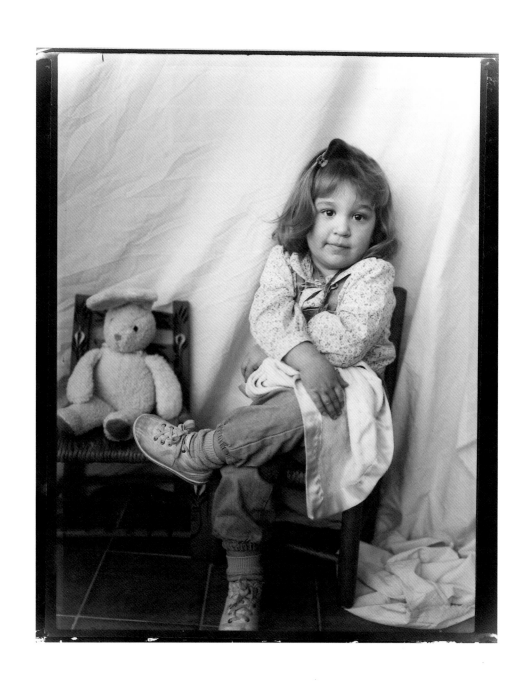

With Bunny and Kiki, **1989**

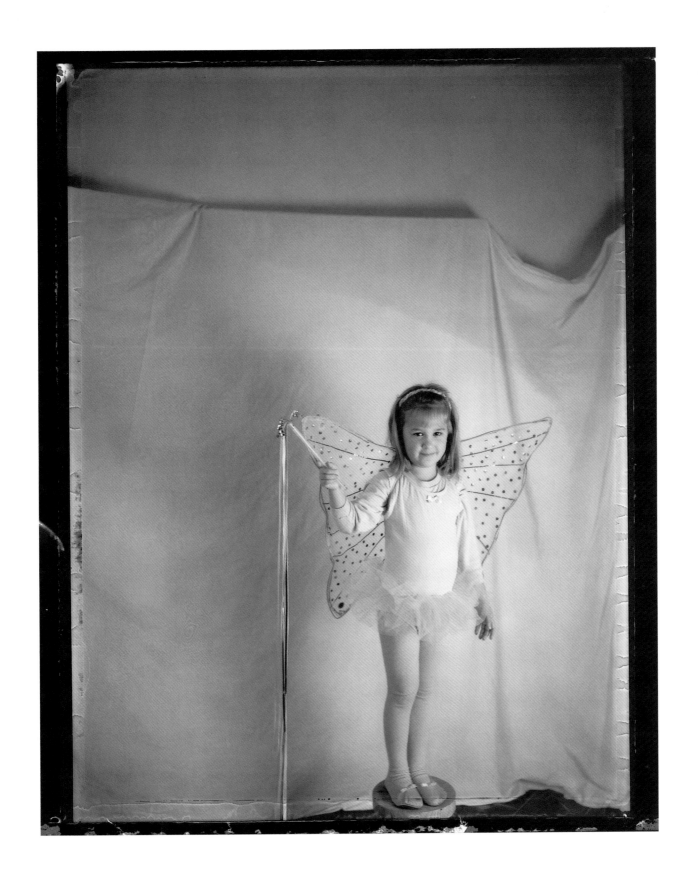

La Fée, **1991**

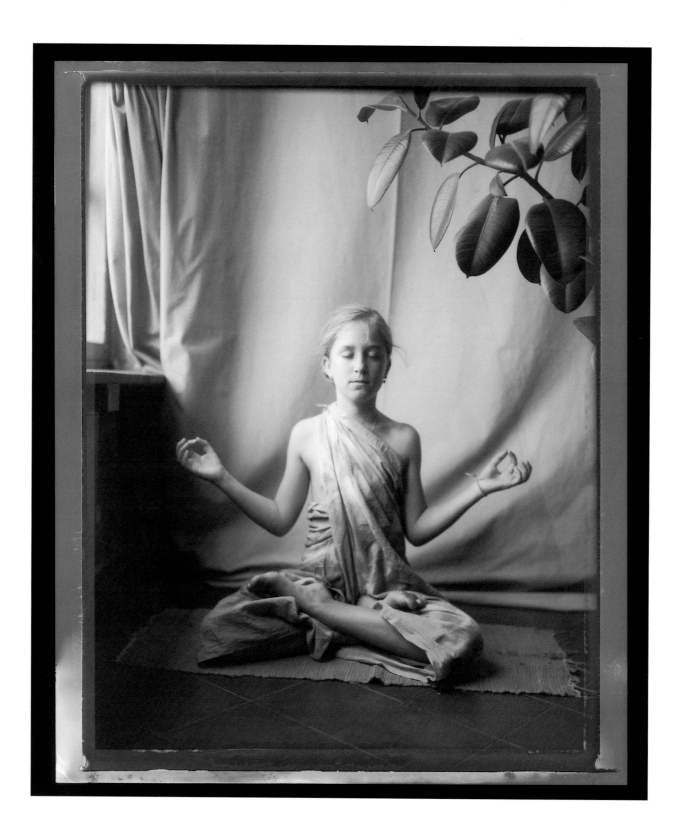

Lotus Position, **1995**

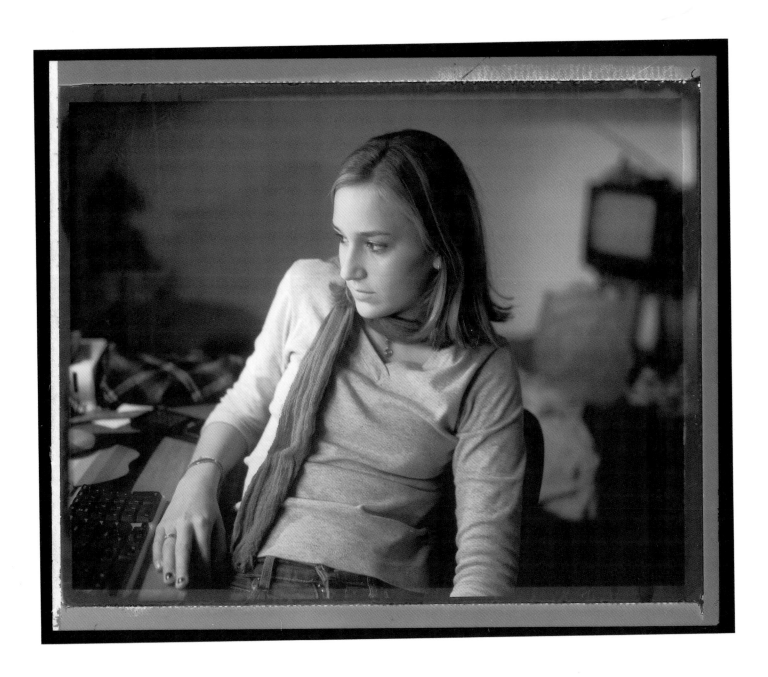

Lucina at Her Computer, **2000**

Lucia Radochonska

"The body of my little daughter Carole is the screen onto which I project my voyages in search of perfumes, of sensations, of music which are probably familiar to me from my own childhood in Poland and . . . which for me are simply indispensable. . . ."

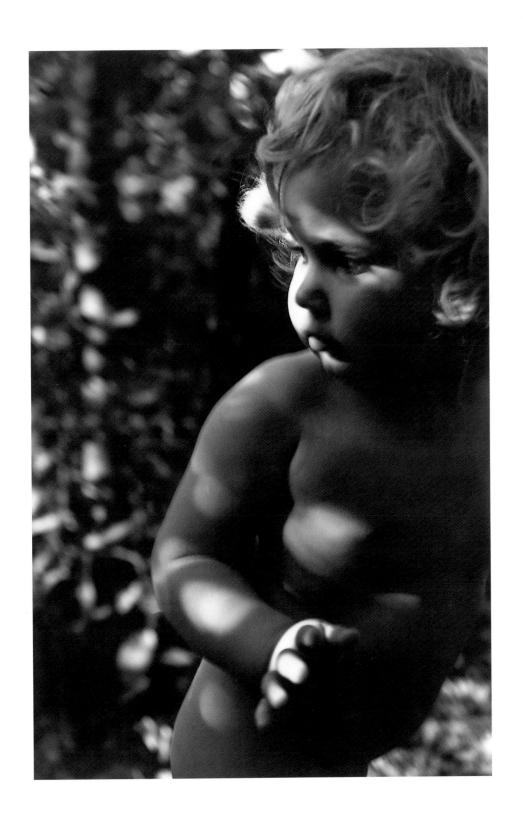

Through Carole I, **1987**

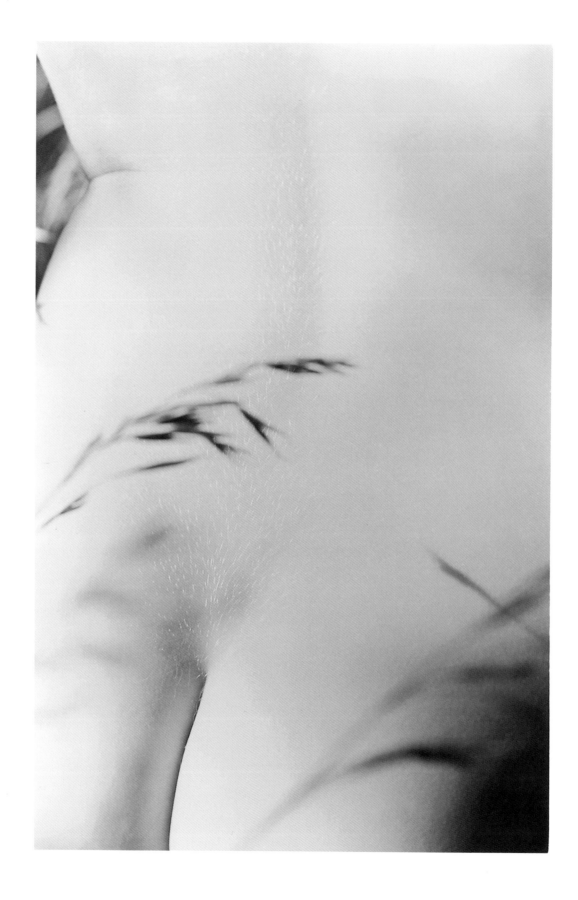

Through Carole II, **1987**

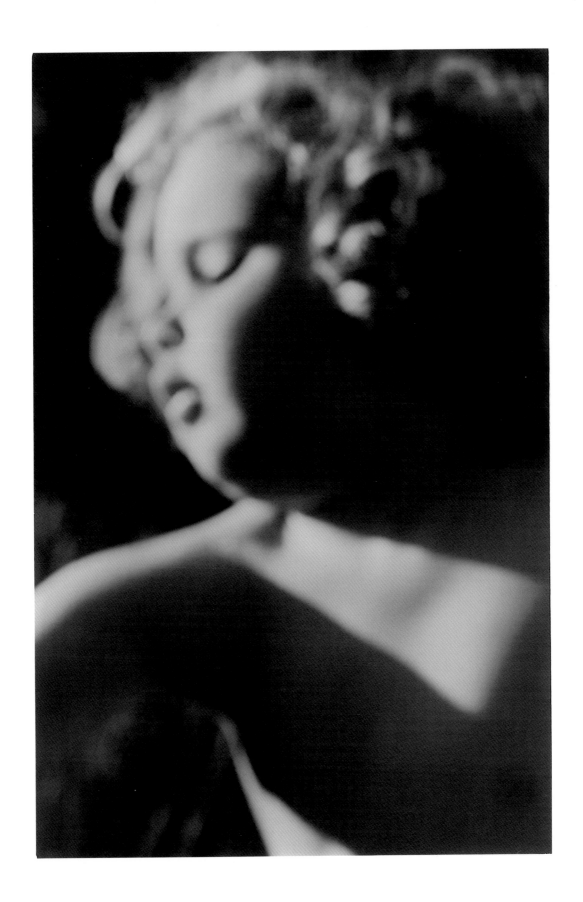

Through Carole III, **1987**

Sheila Metzner

"I started photographing seriously from the moment my first son, Raven, was born. When I saw him, I quit my job as an art director. My children, all five of them, Raven, Bega, Ruby, Stella, and Louie, have been and remain a constant source of inspiration to me. I stayed at home with them for seven years. I would be with them during the day, photographing, and in the darkroom at night. At eight or nine in the evening, when they were all asleep, I would take a shower to wake up and put on high heels and lipstick, which I wore then, to give me the feeling of being ready to work. Those seven years . . . they were the formative years of my work in photography. We spent winters in the city and summers in the country, playing, reading, swimming, gardening, cooking, baking, living. No television, no newspapers or glossy magazines. It was a fairy-tale existence, cut off from the world at large. I dedicated myself to my husband, my children, and photography. I read the autobiographies and biographies of Steichen, Stieglitz, Man Ray, Julia Margret Cameron, and Edward Weston. I had my little ones accompany me to the Met, the Modern, and the few existing photography galleries at that time. The landscape surrounding my country house became Antarctica, Egypt, the world. Those were the most precious, intimate years of my work, and much of it became a series I call "Friends and Family," which was also the title of my first major exhibition at the Daniel Wolf Gallery. After that exhibition and Mirrors and Windows at MOMA, the phone started ringing and my career as a photographer began in earnest. I continued photographing my children, and still do. As they grow and grandchildren arrive, my work evolves. It is their inner life which captivates and inspires me beyond anything else."

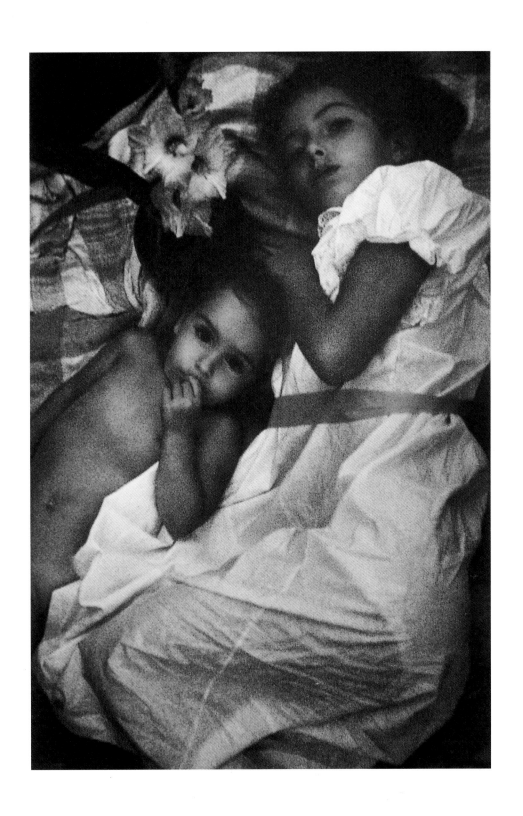

Sisters Chatham, **1985**

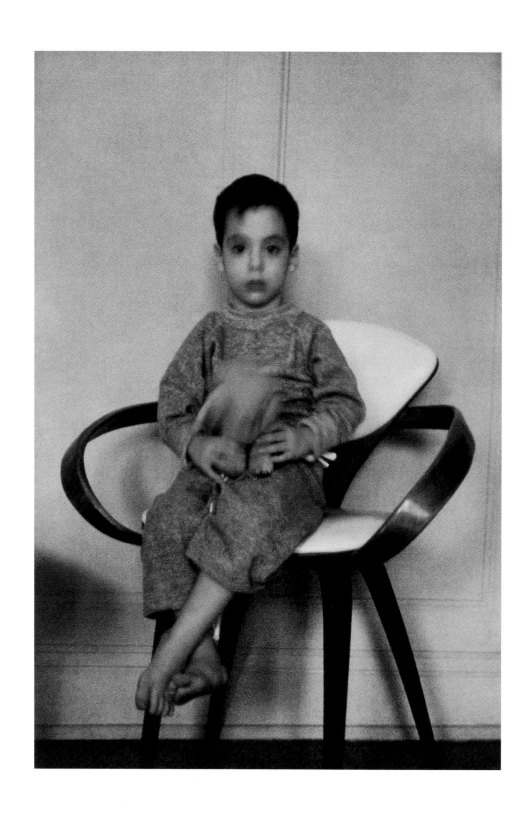

Louie, **1984**

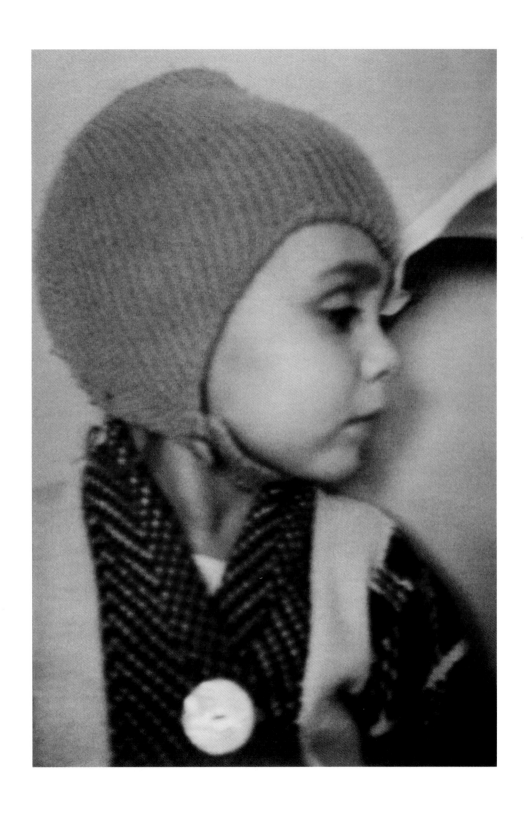

Stella Calla, **1980**

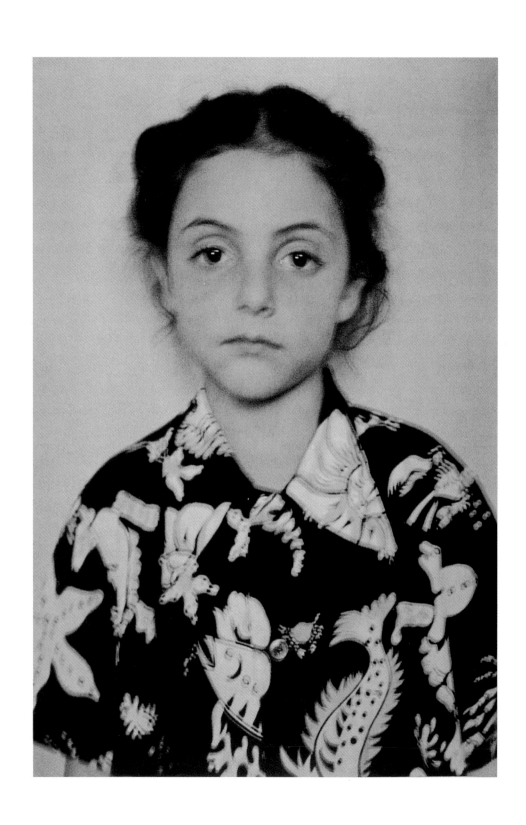

Ruby Miami Shirt, **1980**

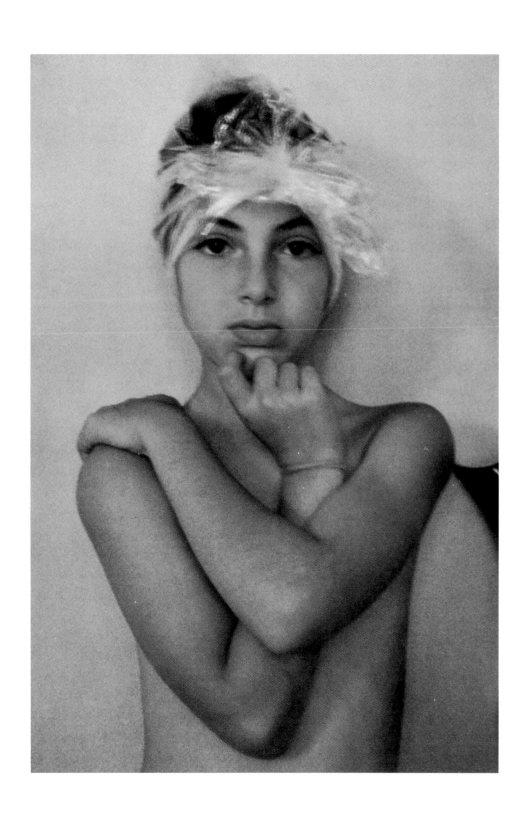

Bega Plastic Hat, **1983**

Annelies Štrba

"With me, everything has a great deal to do with a mystery. There's a mystery behind everything. My photos touch people somewhere deep inside. Something happens, something the viewer cannot explain. And that also relates to this mystery as well."

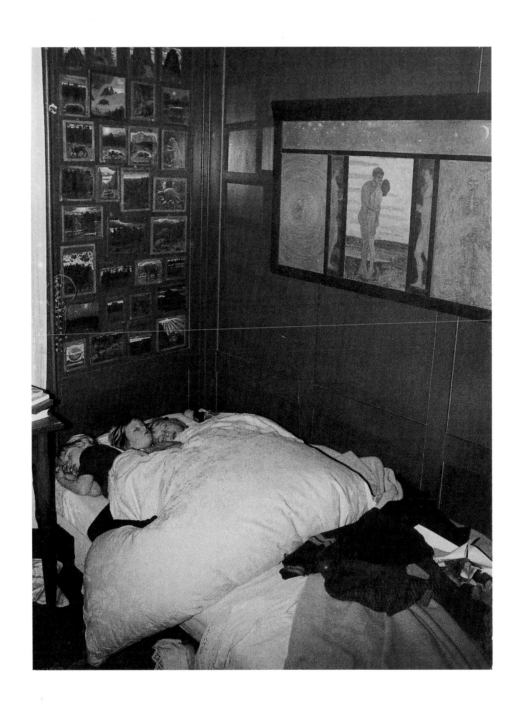

Sonja, Samuel, and Linda, **1977**

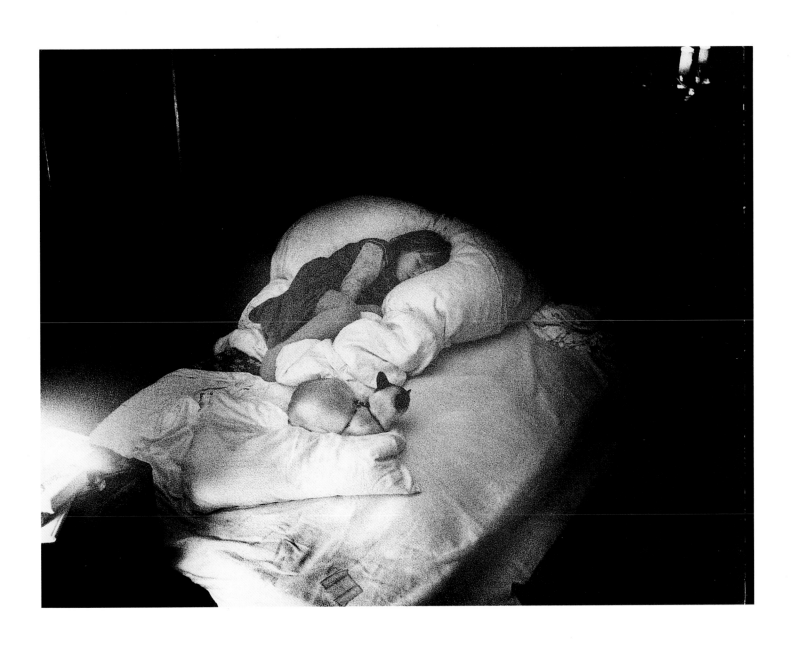

Linda with Kastor, **1978**

Verena von Gagern

"Teresa is the third of four children born within twelve years, and she was my light-medium and my light-catcher from the day of her birth. Back then, I no longer saw light merely as a perceptual bridge between image and reality but as the energy and the object of the image itself. My photographs were never photos of children, nor were they portraits; they were photographs with children—children as authors, as storytellers, as actors who experienced life before my eyes and shaped the pictures I took. My children kept my own childhood alive within me and reminded me of how I have always seen light and perceived space. They were my teachers and my mirror on the journey to my inner self."

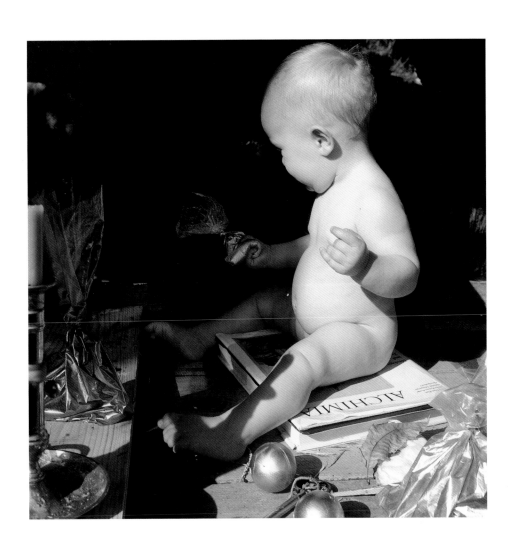

Photography = Alchemy, **1985**

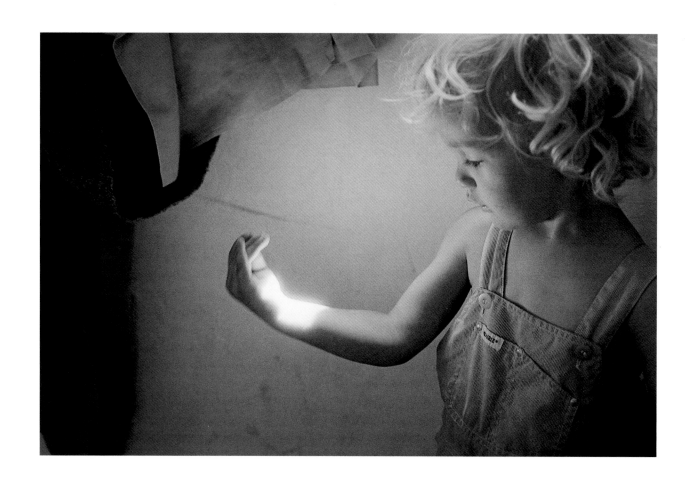

Golden Girl I, **1987**

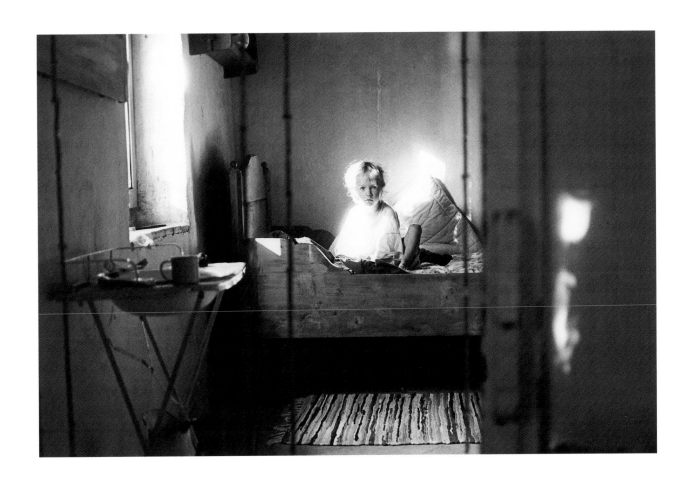

Golden Girl II, **1987**

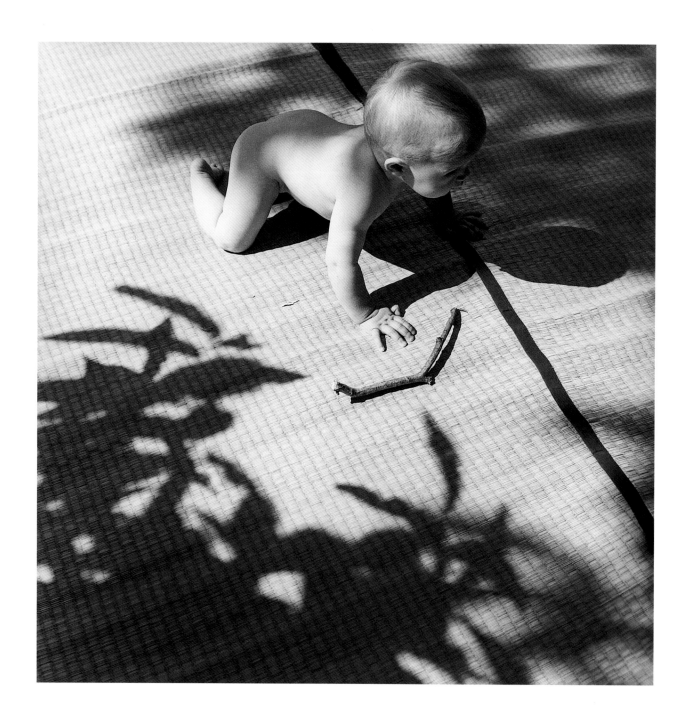

Teresa, **1985**

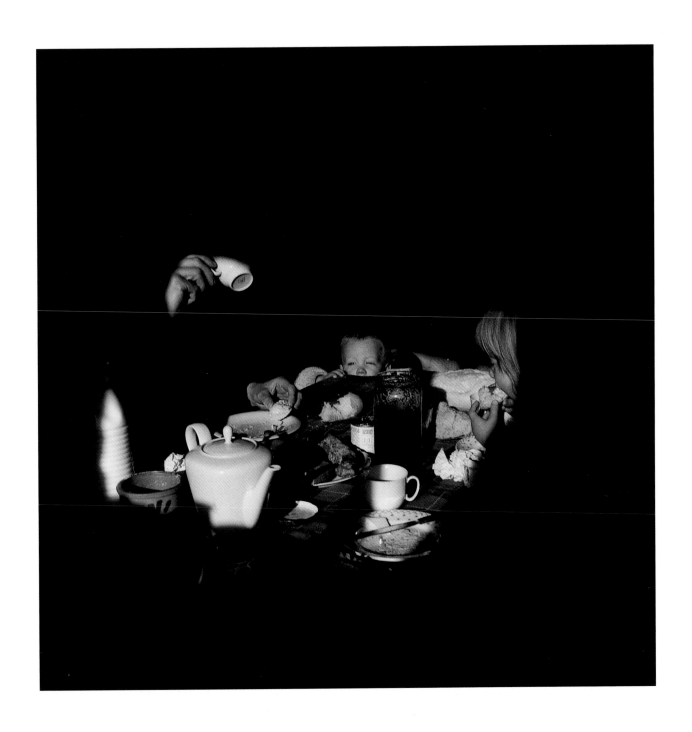

Breakfast, **1975**

Sally Mann

"I struggle with enormous discrepancies: between the reality of motherhood and the image of it, between the love for my home and the need to travel, between the varied and seductive paths of the heart."

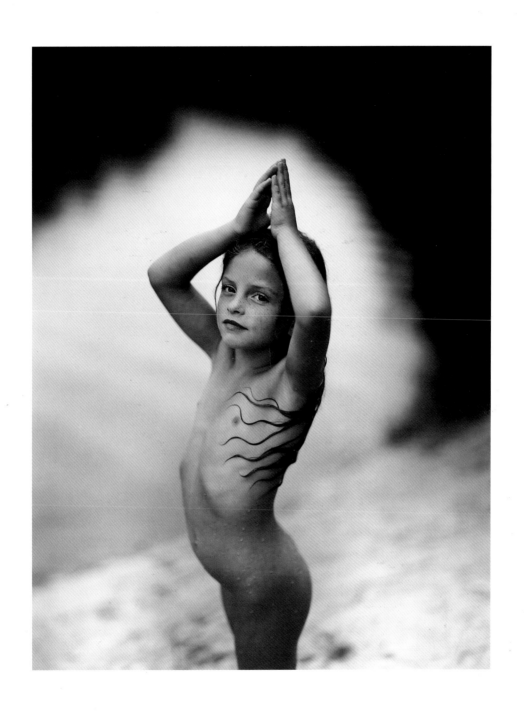

Virginia at 6, **1991**

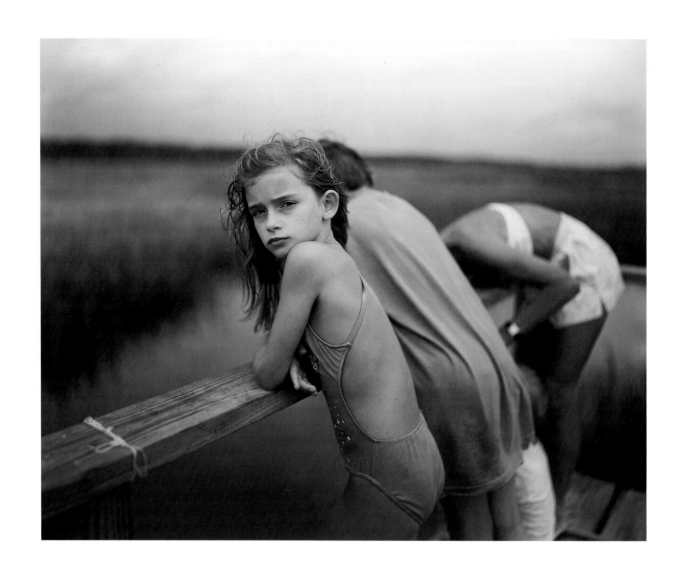

Jessie in the Wind, **1989**

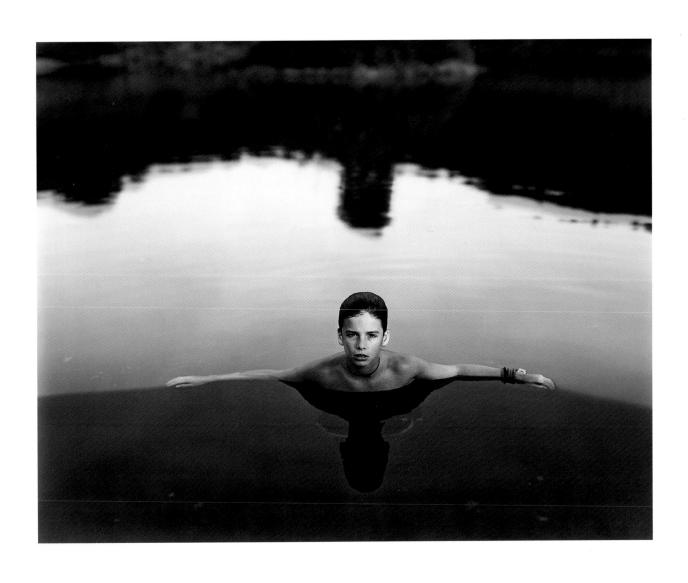

Under Blueberry Hill, **1991**

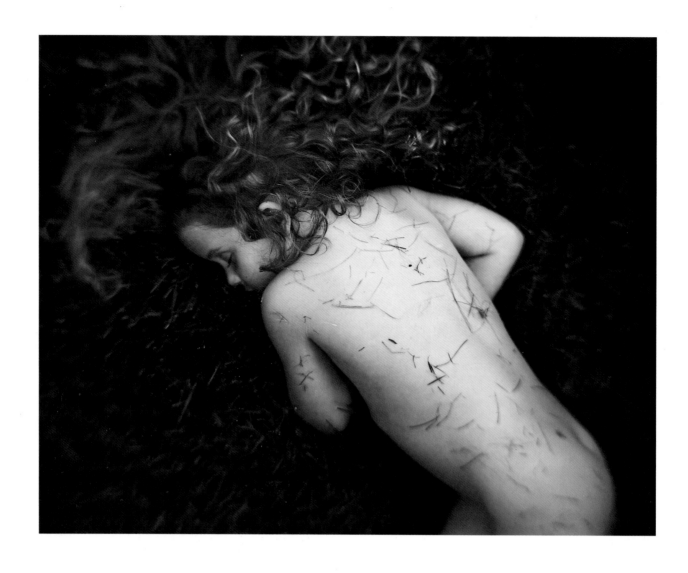

Fallen Child, **1989**

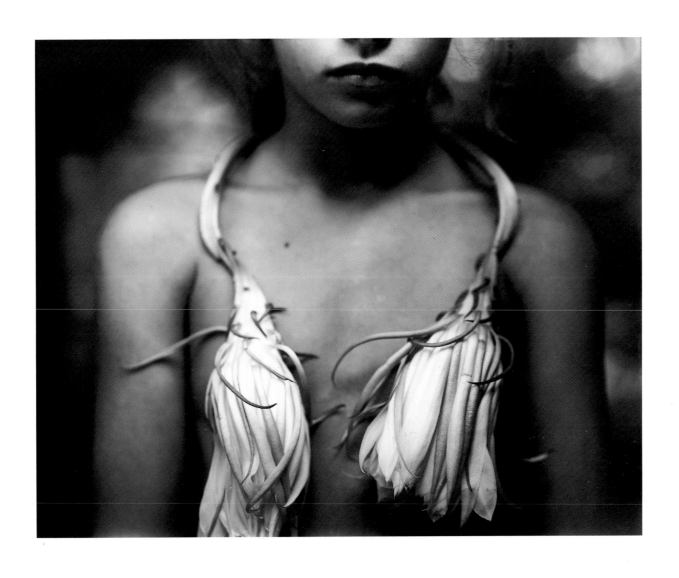

Night Blooming Cereus, **1988**

Debbie Fleming Caffery

"My most creative act has been delivering my children into this world. Their beauty and their enquiring spirits have always been an inspiration to me."

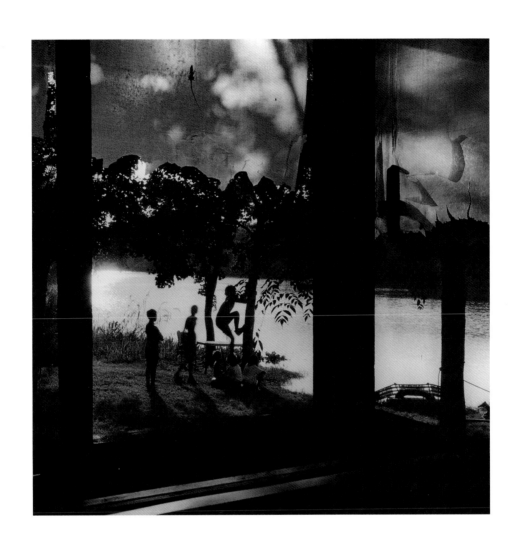

May Van's Camp, September 5, **1987**

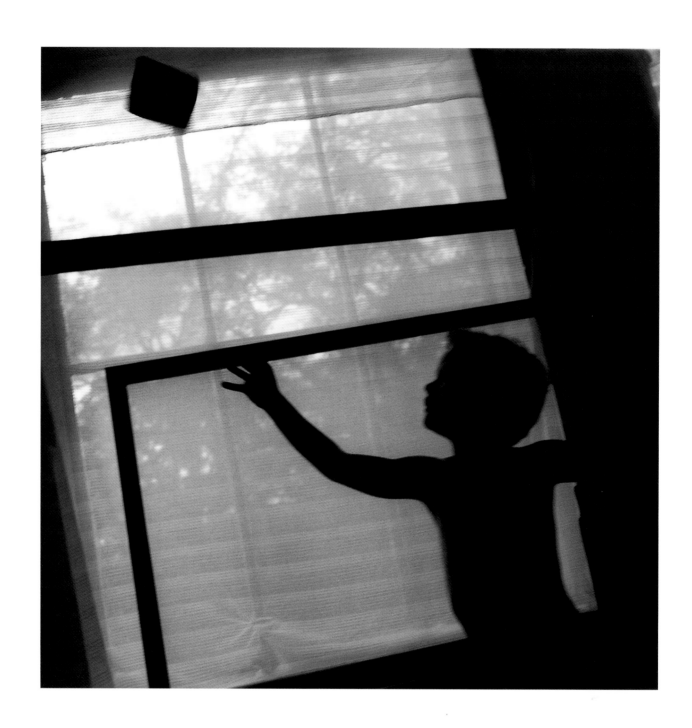

Brennan, Franklin, Louisiana, **1989**

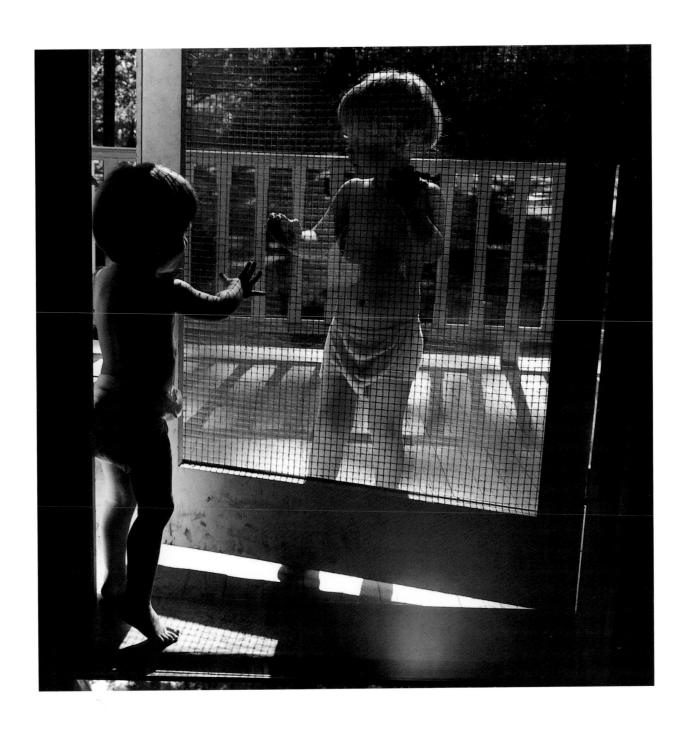

Joshua and Ruth, Franklin, Louisiana, **1979**

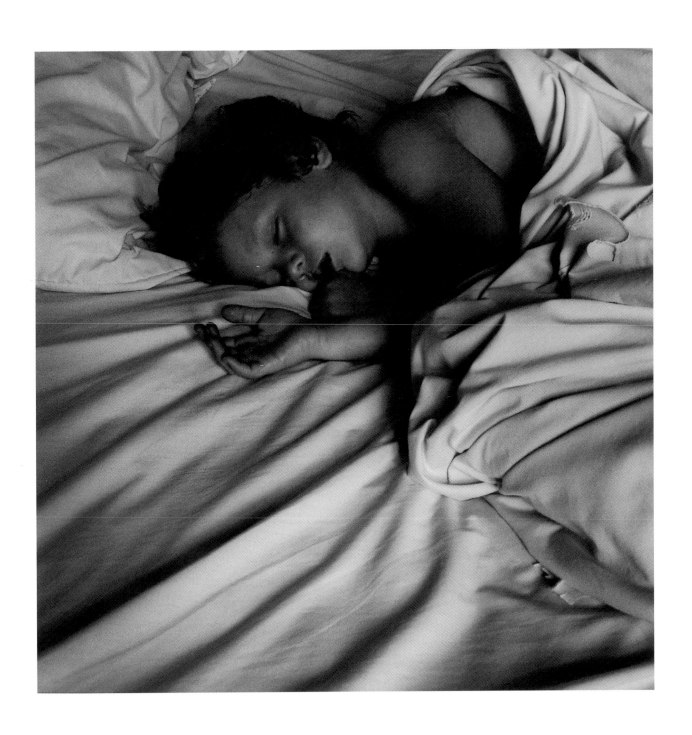

Brennan, Franklin, Louisiana, **1987**

Maude Schuyler Clay

"When I began the portrait work with the Rolleiflex in the very early 1980s—partly as a reaction to a New York City show and book called The New Color *in which there were no people—my aim was simply to take interesting color pictures of people, preferably in the late afternoon light. Many of the color portraits made since late 1986, when my first daughter Anna was born, have been of my children, but I did not set out specifically to do a body of work on my children. Often, the children were simply the people I happened to be with when the light was good and the time was right. They were and still are, for the most part, willing victims. After a while they tend to just ignore my camera and do what they are doing. At other times, they pose, perhaps in an effort to please their mother. I suppose what I hoped for was a cross between the cinéma vérité photography of William Eggleston and the studied portraiture of Julia Margaret Cameron (both were early influences). To my delight, in what has now amounted to a twenty-year project my attempt to make good color portraits has also yielded a record of my beloved children."*

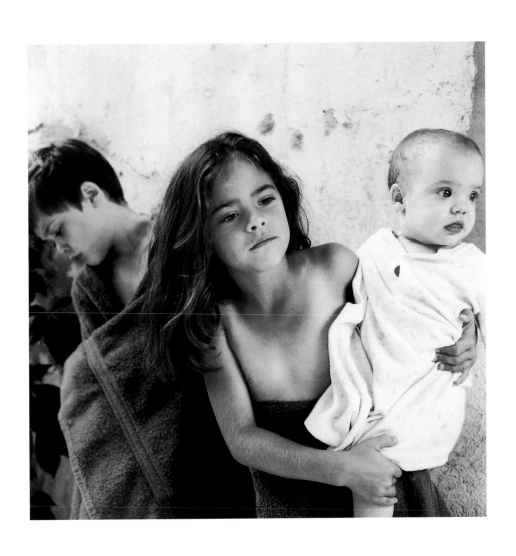

Schuyler, Anna, and Sophie Clay, Hazelfield, West Virginia, **1996**

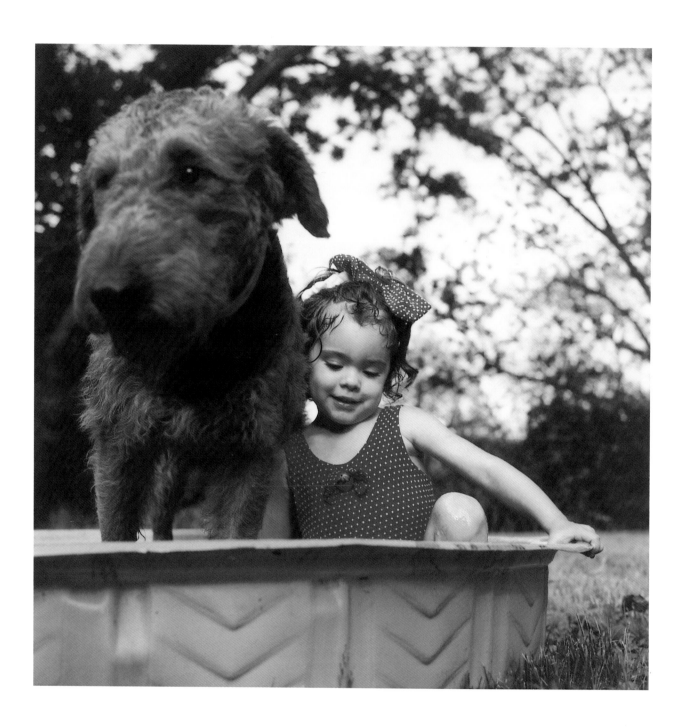

Anna Clay and Elmo, Sumner, Mississippi, **1988**

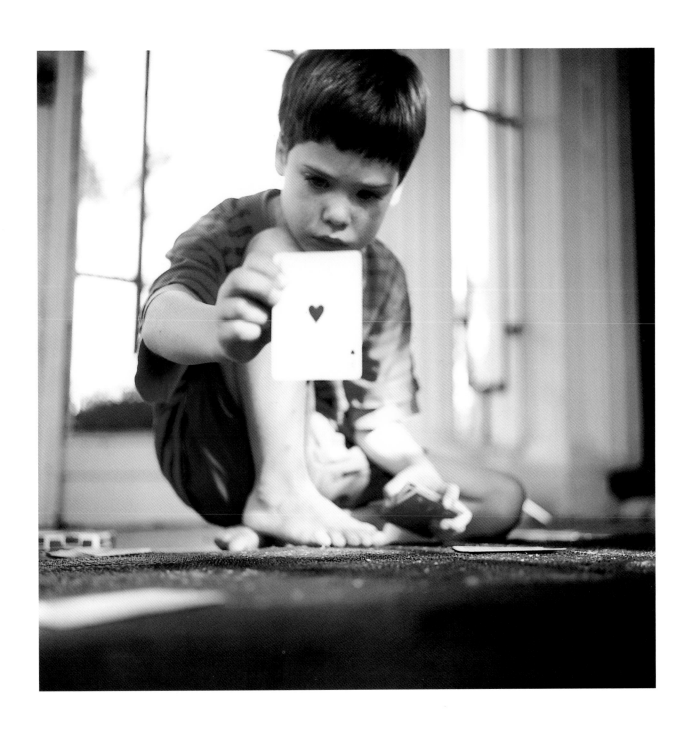

Schuyler Clay, Sumner, Mississippi, **1995**

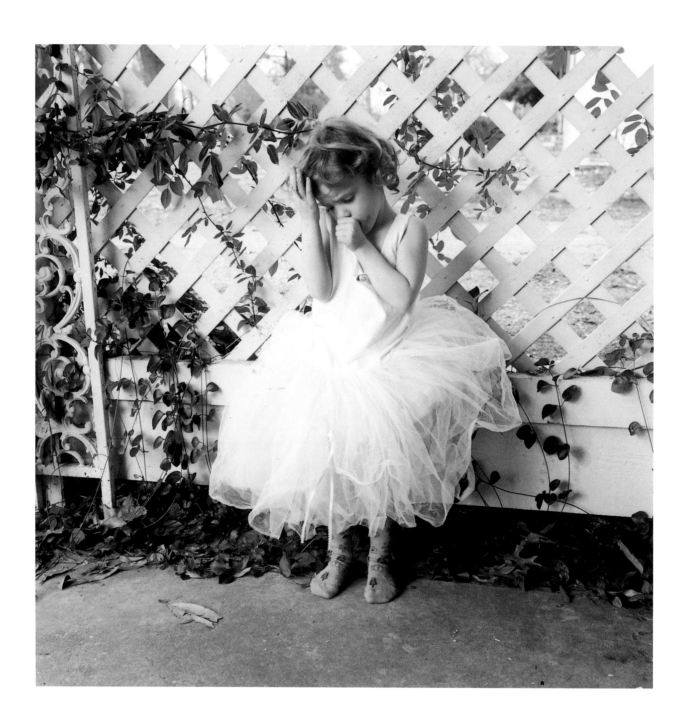

Sophie Clay, Sumner, Mississippi, **1998**

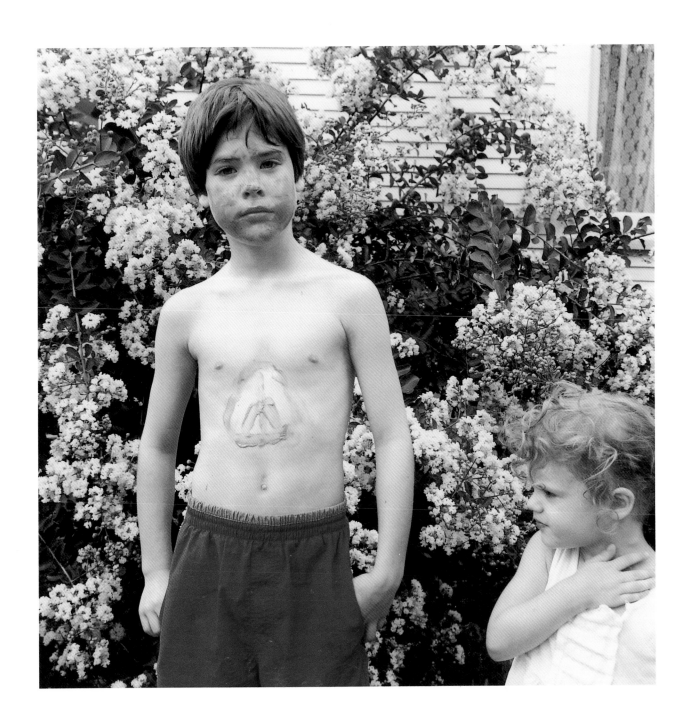

Schuyler and Sophie Clay, Sumner, Mississippi, **1998**

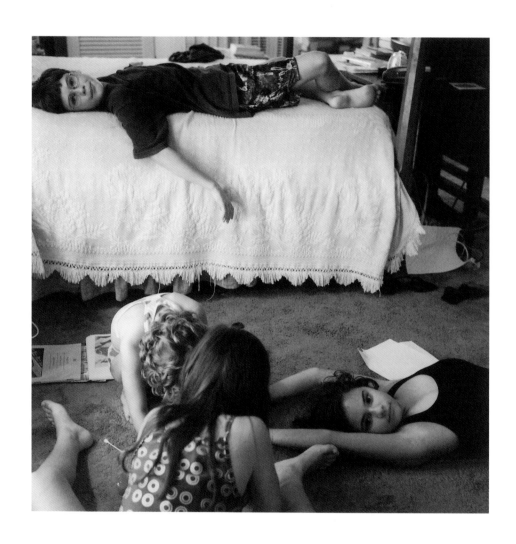

Sophie, Schuyler, and Anna Clay, Sumner, Mississippi, **1999**

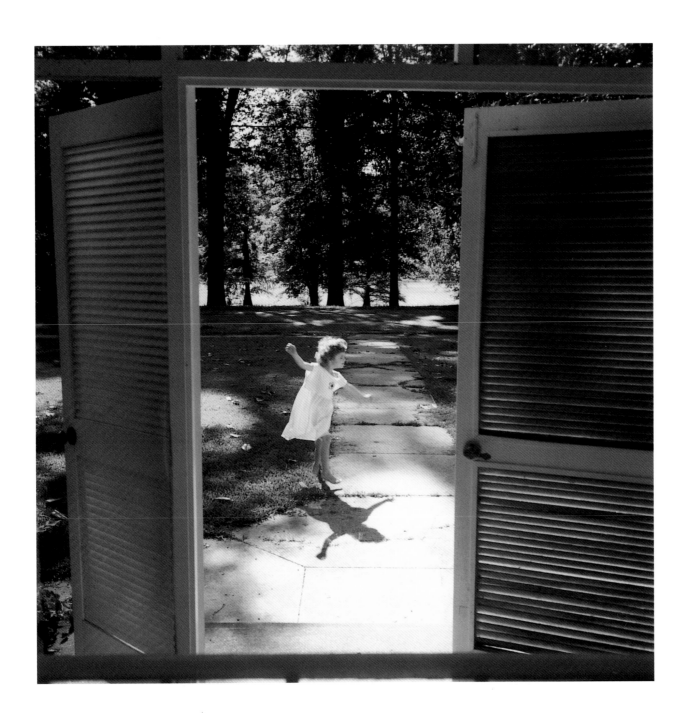

Sophie Clay, Sumner, Mississippi, **1999**

Patricia D. Richards

"My pictures are about what I know: my home, family, friends and neighbors in the spaces we occupy in the decades preceding and following the turn of the twenty-first century. Through the use of an 8x10 camera, life in all of its manifestations has presented itself to my lens and granted me access to daily wonders."

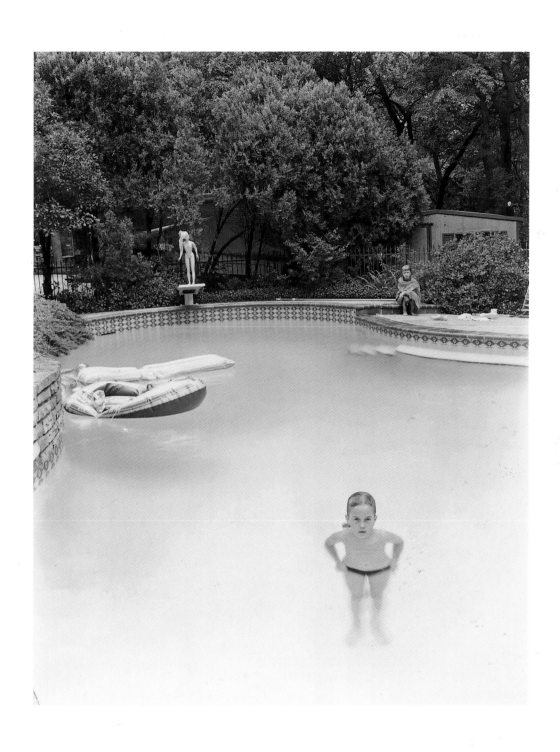

In Hailey's Backyard, **1993**

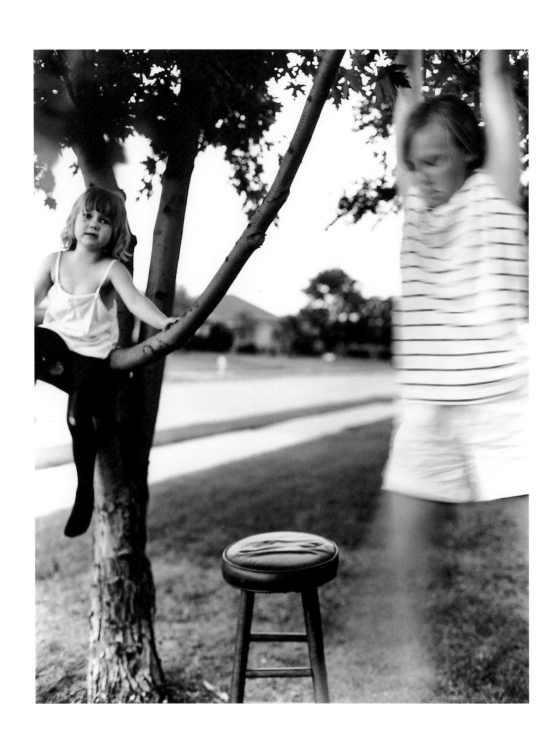

Swinging from a Tree, **1989**

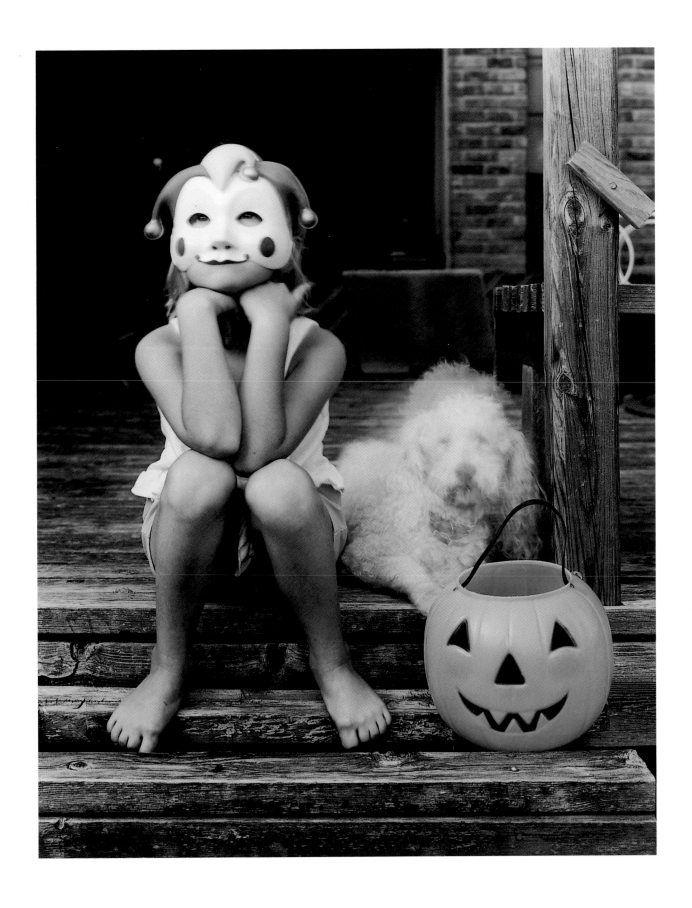

Ghosts, **1992**

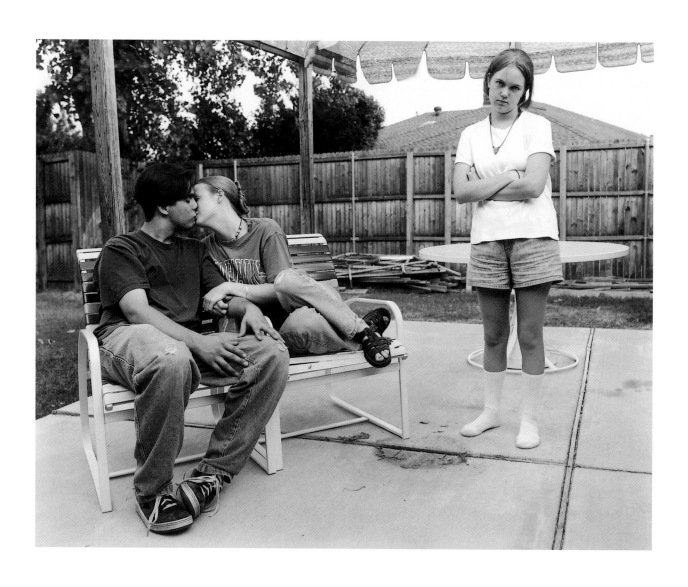

"Please Mom, . . . They're Doing It Again!!!", **1998**

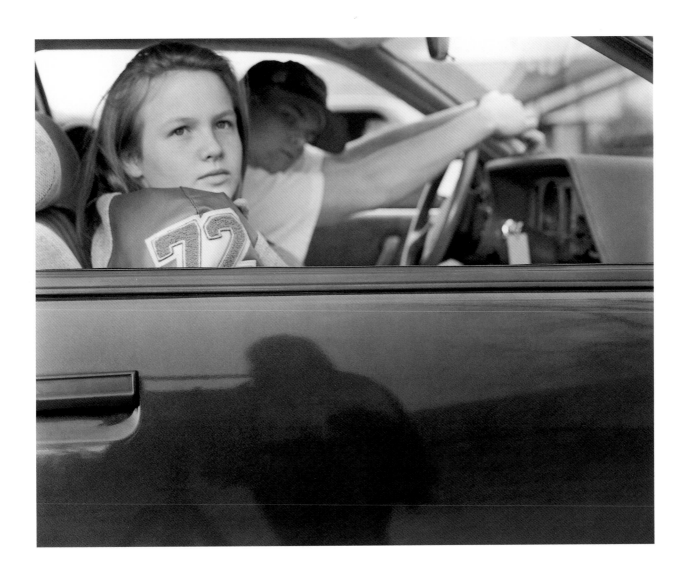

Car/Trouble, **1993**

Deborah Willis

"My work with children began while I was teaching photography in the early sixties, and as a mother I often used the time spent photographing my own child and my nieces and nephew to imagine their lives in the seventies and the concerns of childplay. As I explored their world I thought about the experiences I had had as a child in a segregated society, ones that they do not have to experience today."

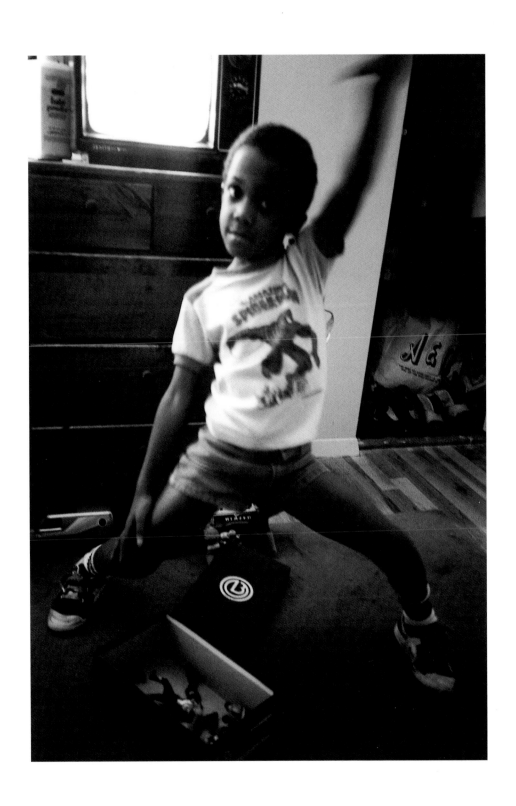

Hank Posing in His Bedroom with His Action Hero Toys, New York, **1985**

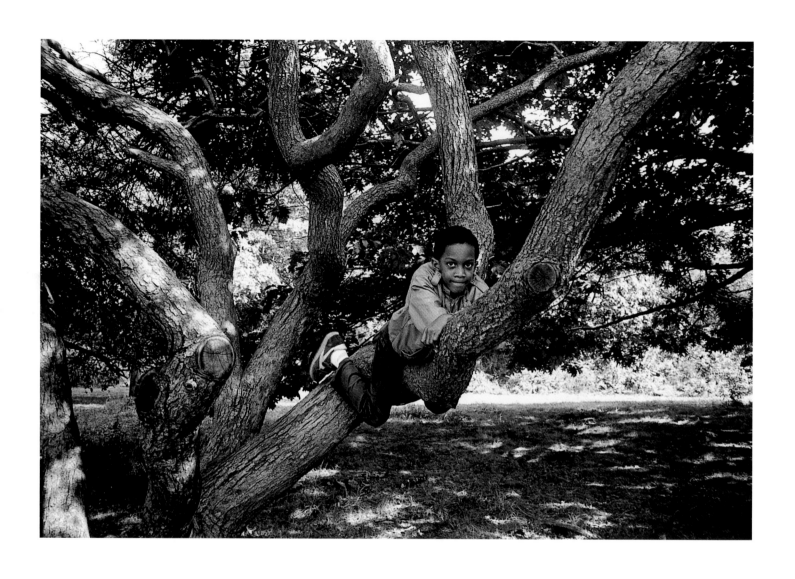

74 *Hank Sloane Thomas*, Central Park, New York City, **1987**

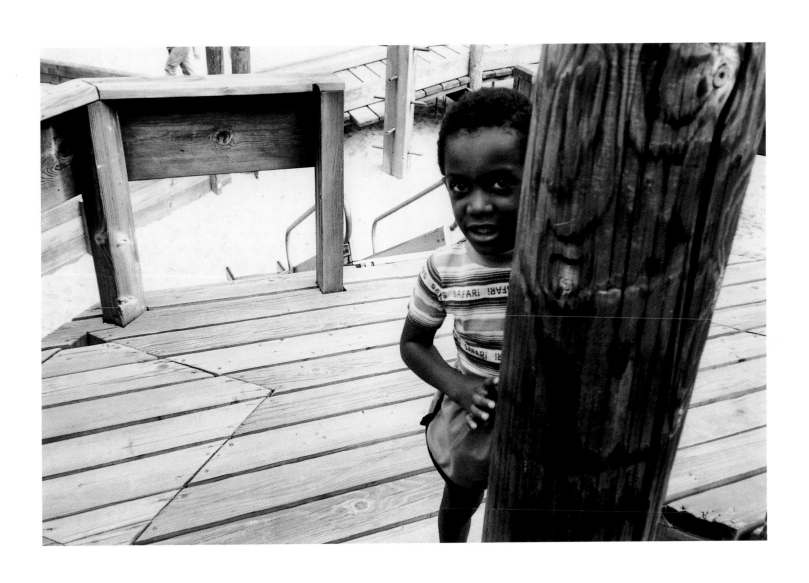

Hank Sloane Thomas, Central Park, Sand Box, New York City, **1982**

Esther Haase

"I really photograph my daughter Marlene much as any other mother would—when she loses her first teeth, her first day at school, trying on my high heels, or showing off her terrific blue lollipop tongue. Marlene loves dressing up and painting her face with lipstick, just as most kids do.

The idea is to capture wonderful moments in life. Shootings are part of my life, and the stylists often put together the most beautiful collections of costumes for Marlene. The kinds of things I have to stage on the job come naturally to Marlene when I'm taking her picture. She is free, uninhibited, and honest."

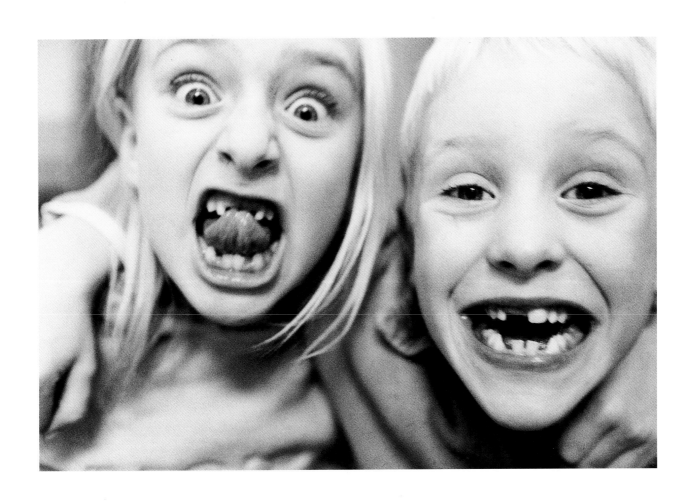

Marlene, **2000**

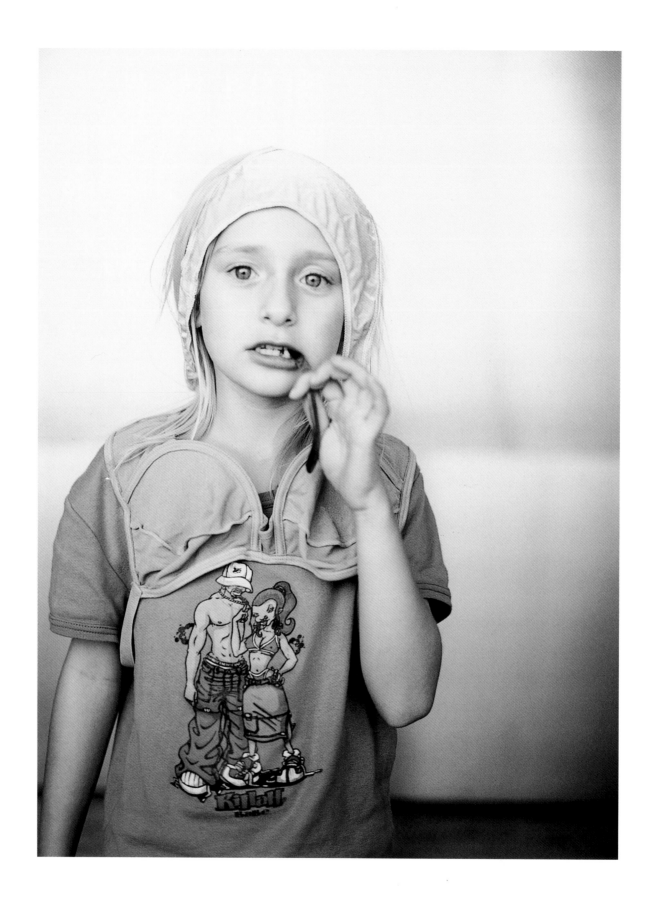

Marlene, **2000**

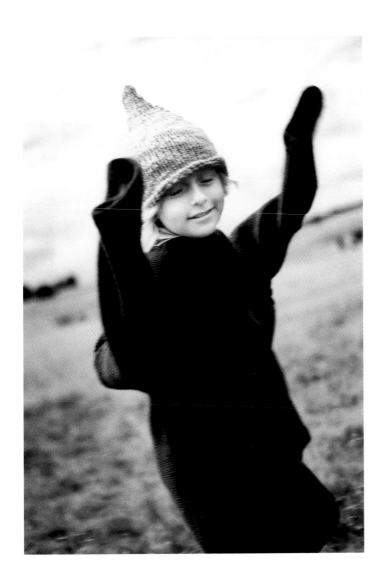

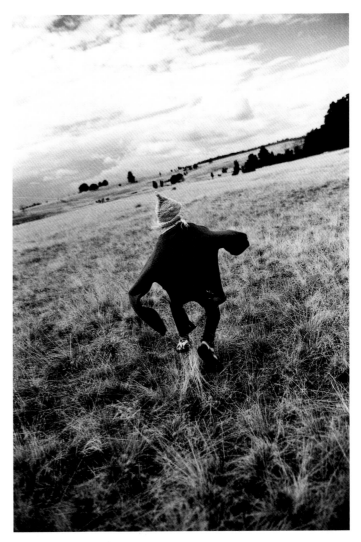

Marlene, **1999**

Britta Holzapfl

"An avid photographer from the age of seventeen, after the birth of my two daughters and my son I began to record their physical and emotional development, the astonished and happy, serious and cheerful looks on their faces—in short the whole amusing and fascinatingly different world of children—in photographs.

The intensity of a gaze or a seemingly random pose can awaken my interest as a photographer at any given moment. I reach for my camera and capture what lies before me on one or several rolls of film.

That my portrait subjects are also my own children is a very important aspect of my work. I can hardly imagine them behaving so openly and unselfconsciously in the presence of anyone unfamiliar to them, no matter how friendly he or she may be. Immediacy and body language, the aspects most important to me in my photography, can find expression under these conditions, as can—on the other side of the camera—the tenderness in a mother's eyes as she gazes at her children."

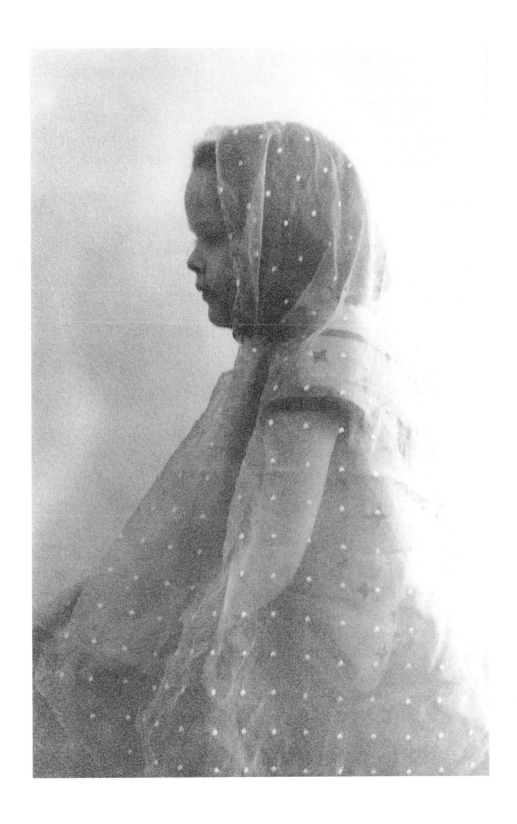

Charlotte Dressed As a Fairy, **1991**

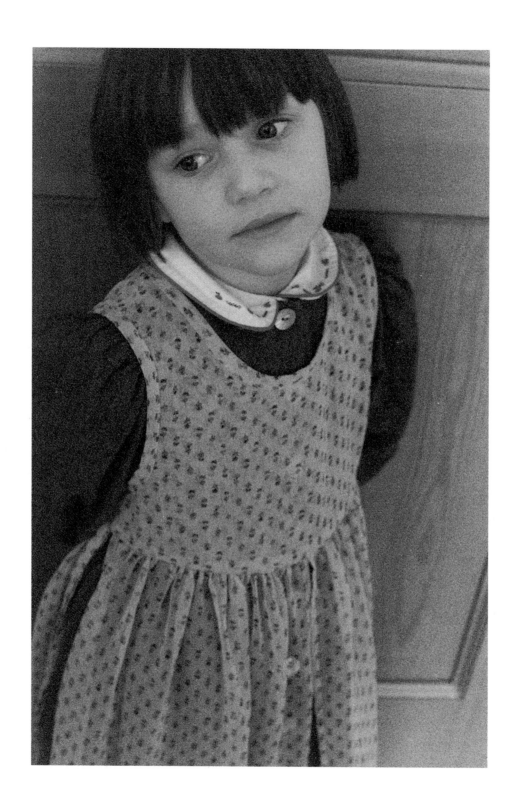

Cosima at Age 4, **2000**

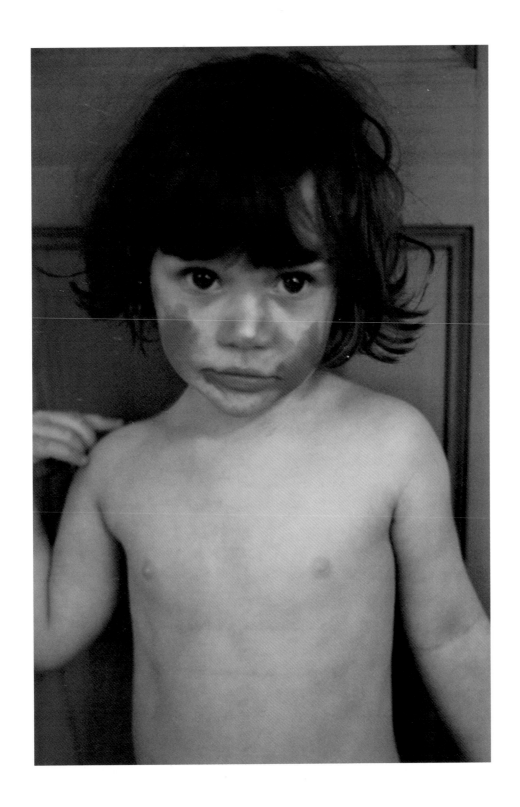

Theater Make-up, **1998**

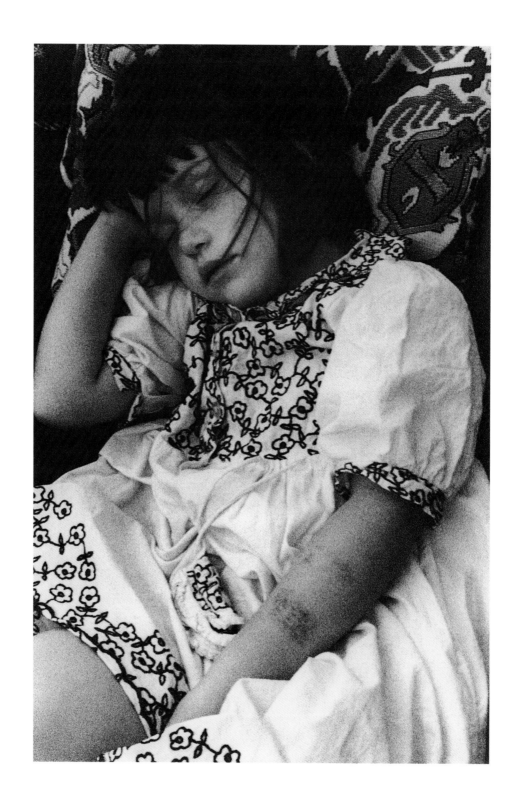

Cosima, Asleep on the Couch, **2000**

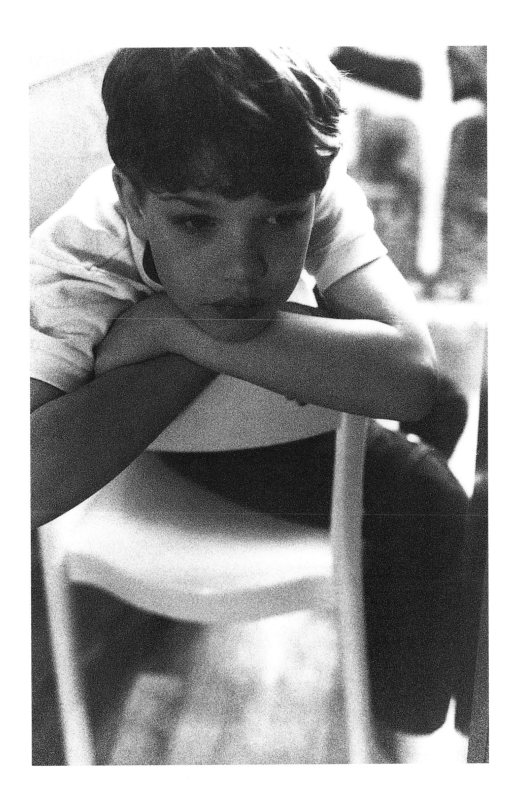

Tristan at Age 10, **2001**

Joyce Tenneson

"My son Alex is now twenty-eight and is getting married next week. He is my only child. For the wedding rehearsal dinner I have put together a slide show of photographs of him from birth to the present moment. There are many humorous and playful photos—Alex blowing bubble-gum, and Alex swimming, feet high in the air. There are also what I call the memento photos—Alex and his grandparents, graduation, school plays and photos that mark the different public moments that are a part of our shared culture. But the photographs that haunt me are the ones I took simply to document the beauty and purity of Alex's soul.

I have always felt that my greatest gift in life has unequivocally been my son. I cannot imagine not having had this relationship. My best photographs of him are acts of honoring and capturing the beauty and complexity of his being. Photographing my son was like opening a window on an exotic and mysterious world and his outer and inner radiance at times left me breathless.

I was always careful to respect Alex's boundaries. As a mother, I was protective of what I felt he was and would be comfortable with revealing. I never wanted him to come back as an adult and accuse me of using him. In fact, when he was about ten years old Alex told me he didn't like being photographed anymore. He was entering a phase of his own personal journey where there was a need for privacy.

I feel blessed to have a portfolio of images of Alex during those first ten years that continue to touch my heart."

July 2001

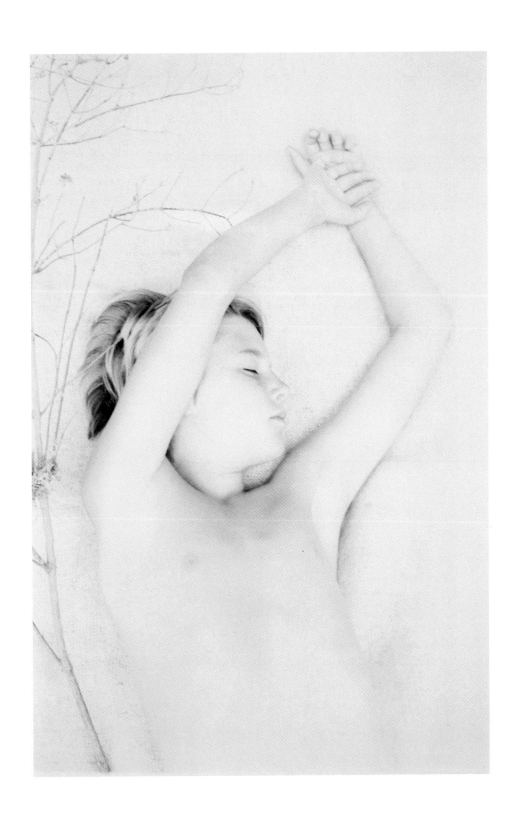

Alex, Untitled #1, Age 8

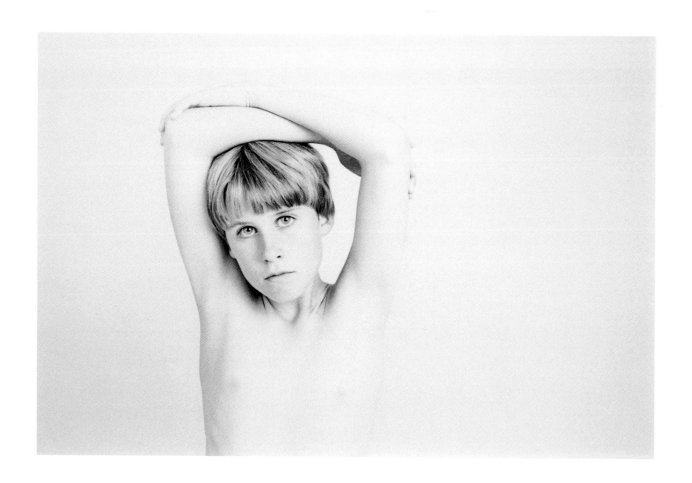

Alex, Untitled #2, Age 9

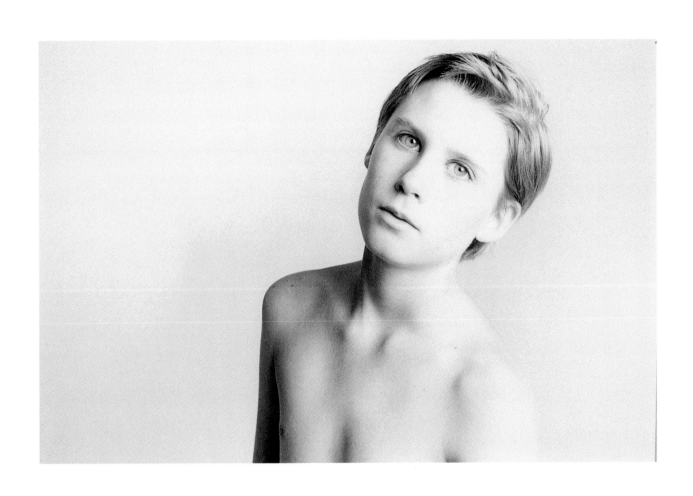

Alex, Untitled #3, Age 10

Niki Berg

"It was a privilege to photograph Karina as she moved from childhood to womanhood. The work gave us time together to pause. To look. To wonder. To question. To connect. To engage. To love."

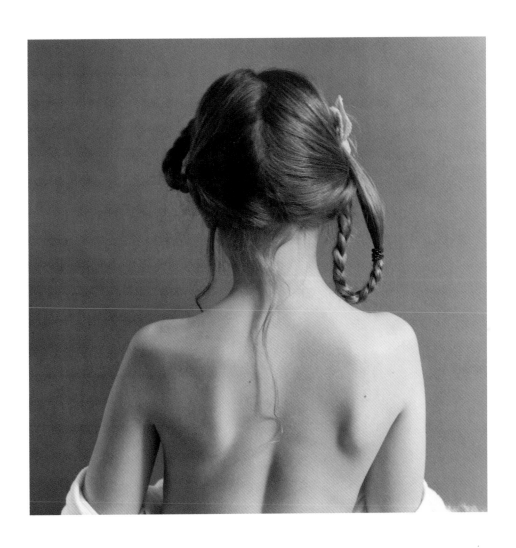

Karina after Bath, March **1980**

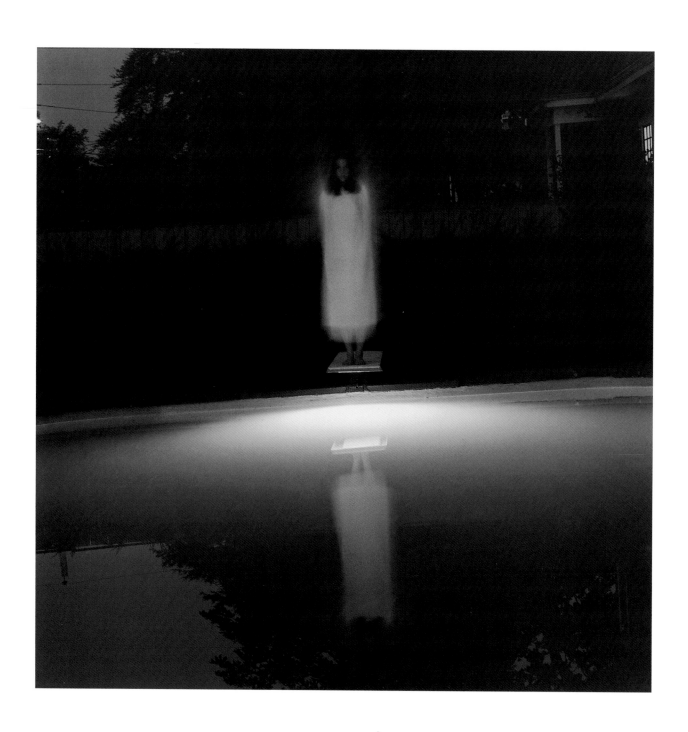

Karina Ascending, July **1985**

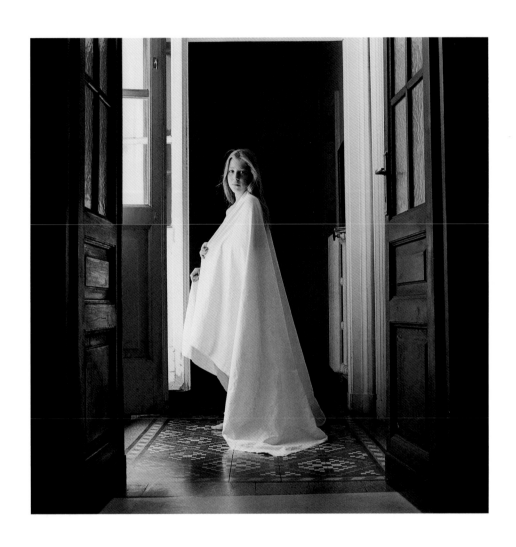

Karina in Rome, August **1980**

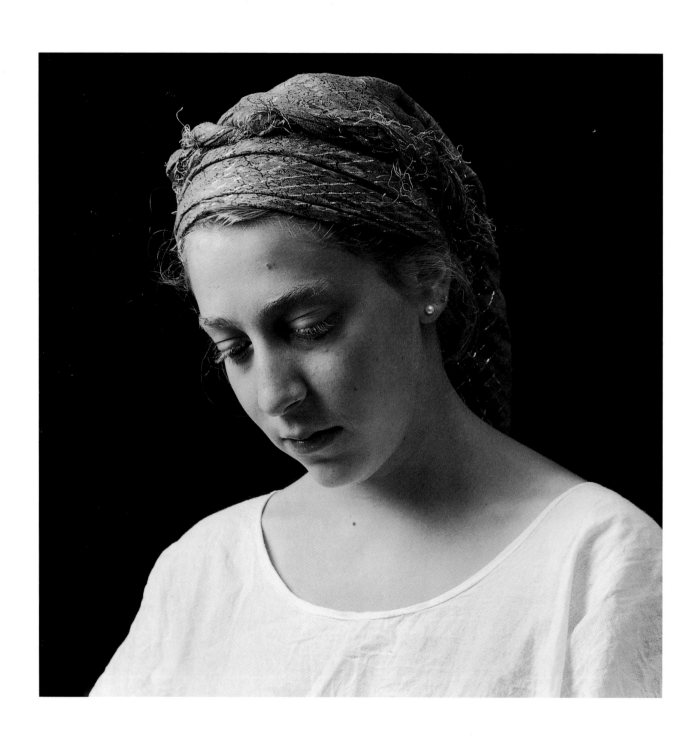

Karina after Europe, September **1989**

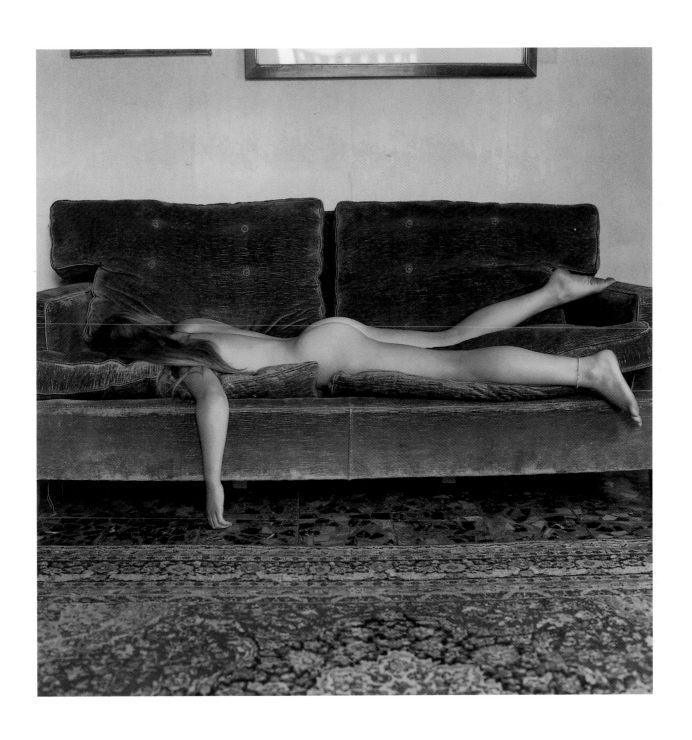

Karina on Couch, August **1980**

Flor Garduño

"The birth of my children changed the way I worked as a photographer, and gave me the opportunity to use approaches I had discovered early in my career but had never pursued further. The human and emotional input from Azul and Olin and our shared interest in this work opened a window onto a new world for me.

I find it easy to work with Azul. I can approach her playfully, since the distance I sense initially in working with an unfamiliar model is not there, and I can discover and express my creativity calmly and effortlessly in our familiar surroundings. "

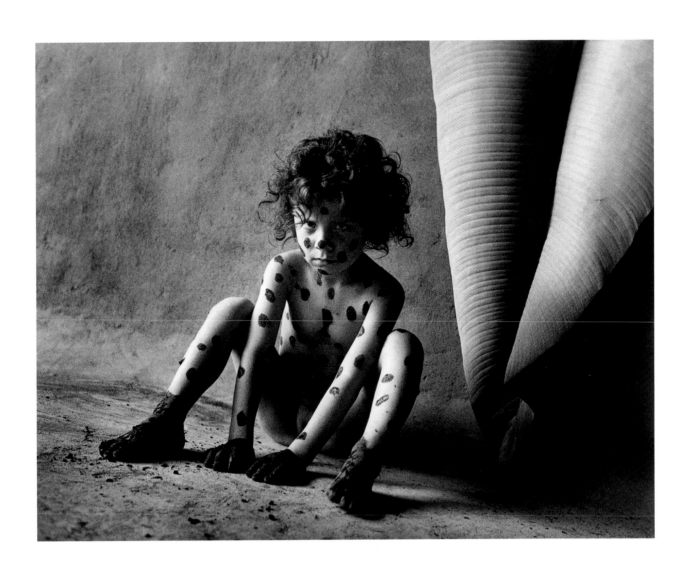

Azul Oceolote, Mexico, **1998**

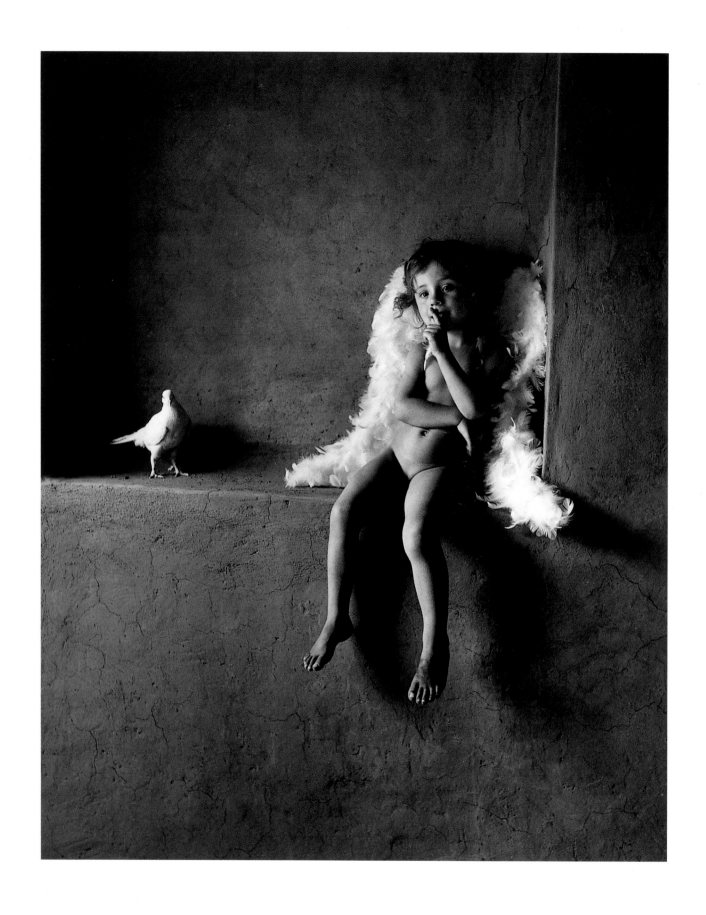

Paloma, Mexico, **1997**

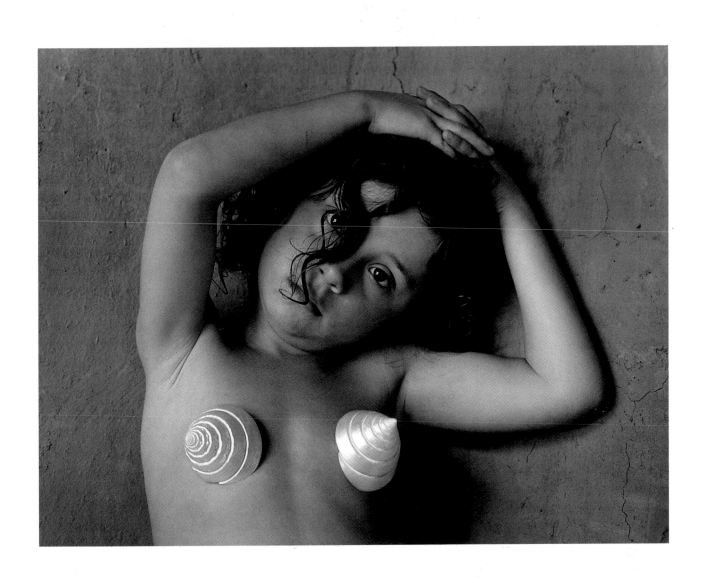

Mar Azul, Mexico, **1998**

Nancy Marshall

"It was natural to make pictures of my children, Katherine and Patrick, from the day they were born. Although I am primarily a landscape photographer, photographing my children was something I enjoyed doing all along. The photographs were done spontaneously, almost like snapshots. There were some situations where I tried to work out something more complex. I use a view camera and make contact prints of the large negatives in the processes of platinum and palladium."

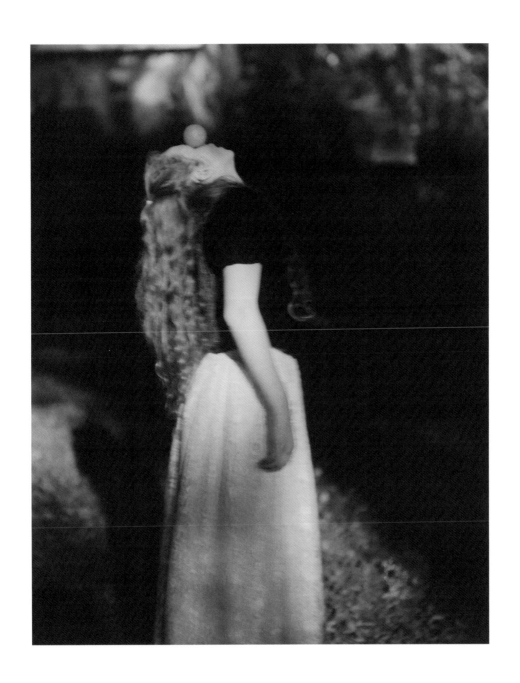

Katy, Age 13, **1994**

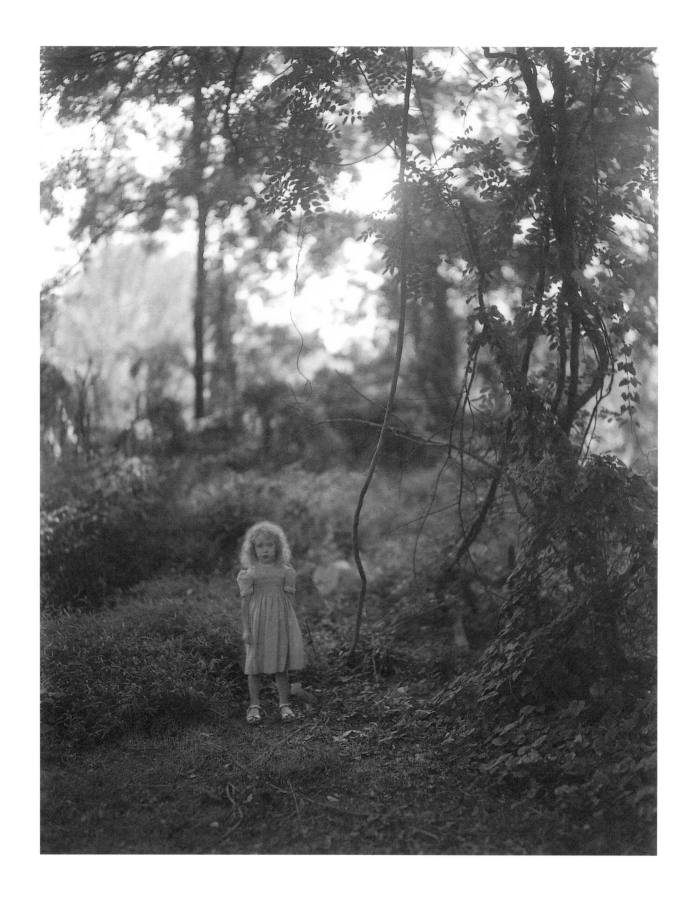

Katy, **1984**

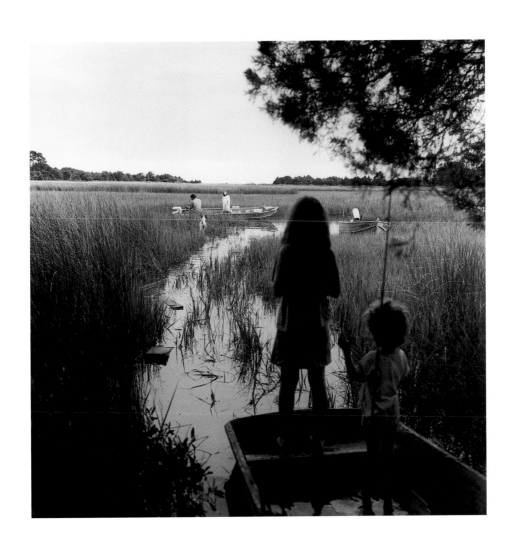

Katy and Patrick, **1987**

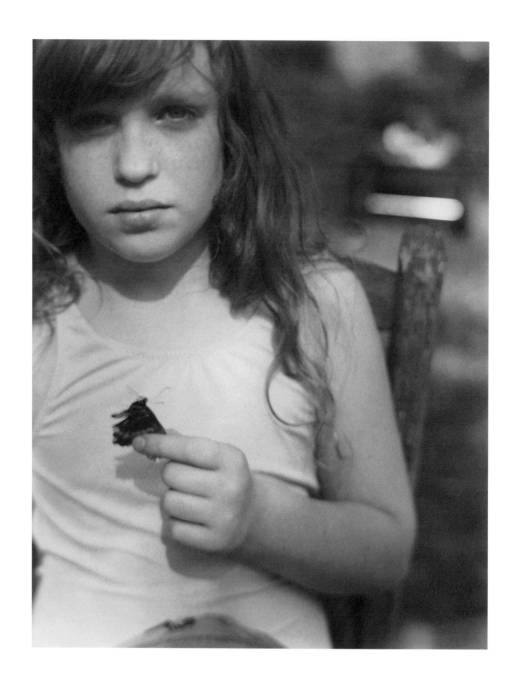

Katy, **1989**

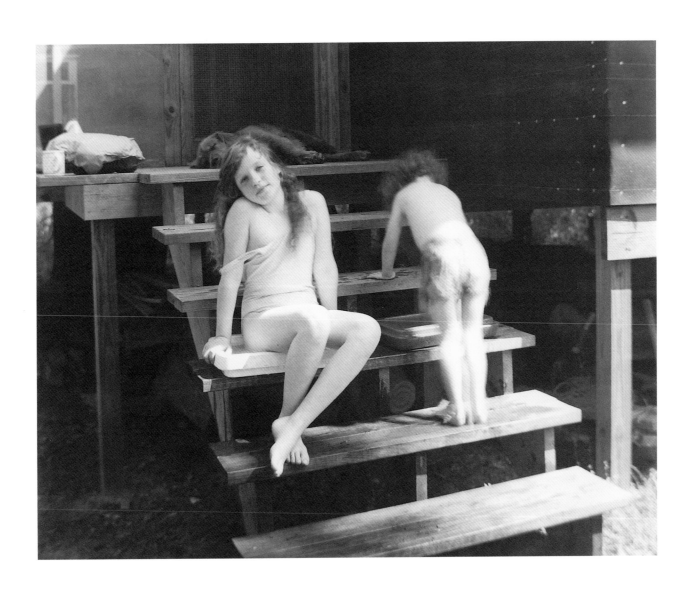

Katy and Patrick, South Carolina, **1989**

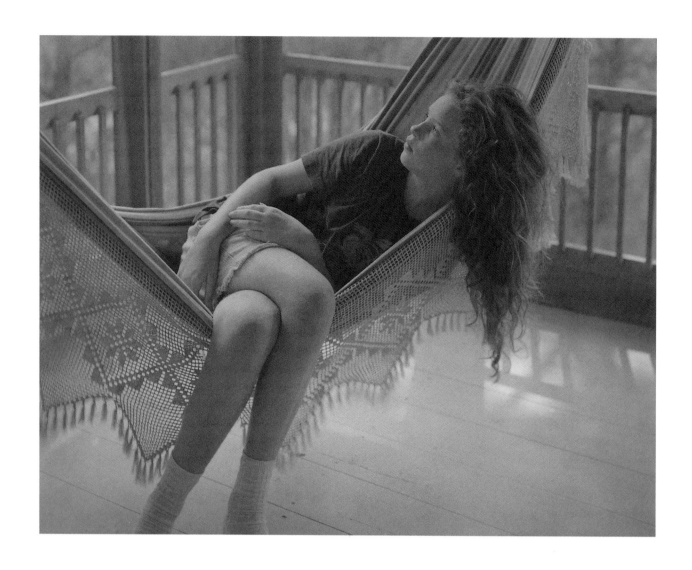

Katy, **1993**

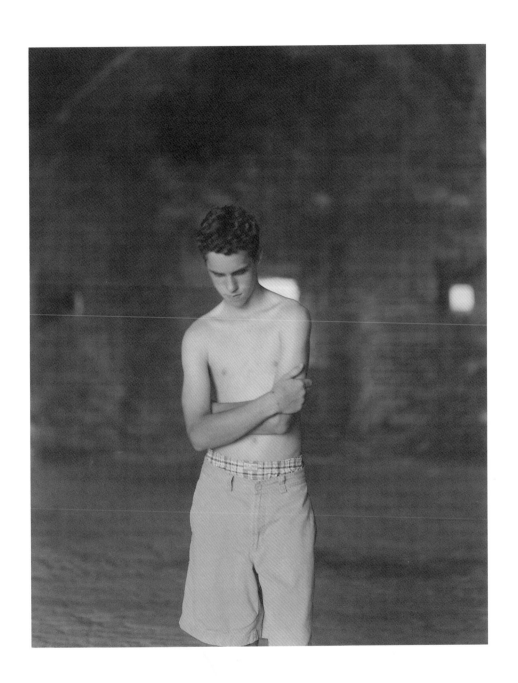

Patrick, Fort Morgan, **1999**

Sandi Fellman

"These are both images of my son Zander and husband Charlie. Now that Zander is as he says a 'pre-teen,' these photographs are all the more poignant memories of an earlier time in our lives together, and the innocence and tenderness of childhood."

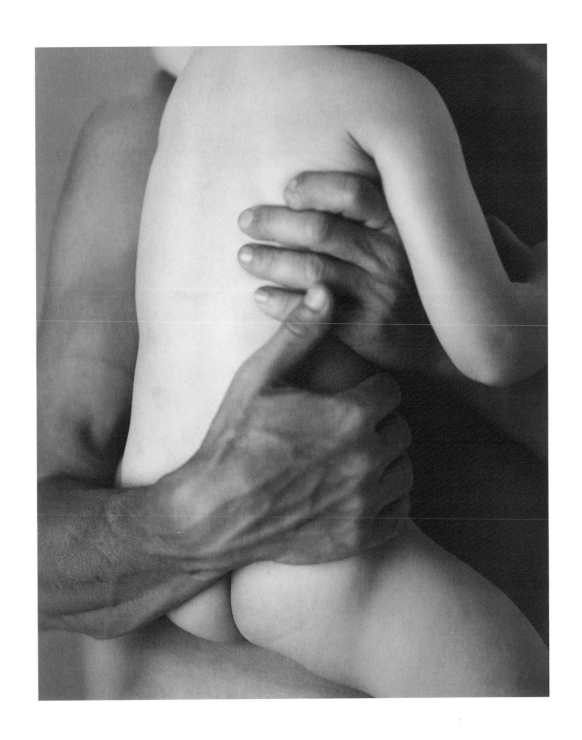

Untitled, **1994**

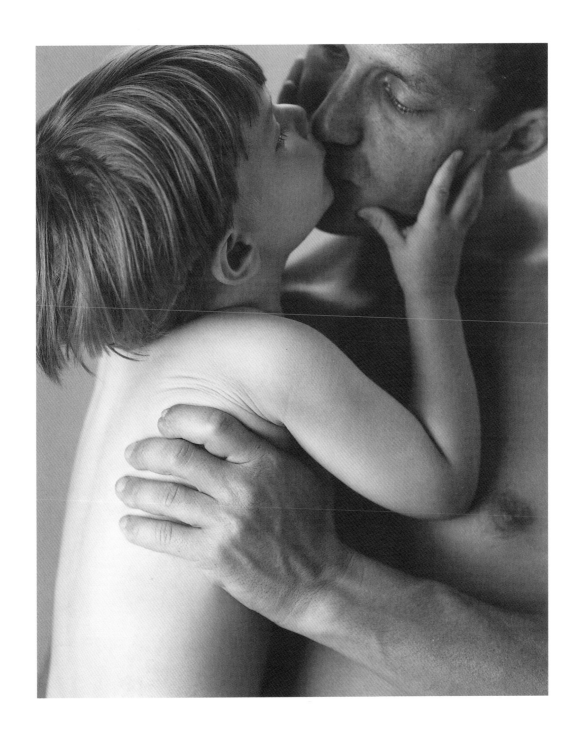

Untitled, **1994**

Mary Motley Kalergis

"These three photographs are from a series I made in 1981 after the birth of my second son. As a documentary photographer, I was used to traveling outside the home and examining the lives of strangers with my camera. An infant to be nursed and an active toddler made my vocation nearly impossible, so I turned my camera towards those closest to me, who were simultaneously keeping me from my creative work while forcing me to dig deeper and take new risks. A mother lives on the front line and in the trenches of the human condition, which is the medium which inspires the documentary photographer. I've since gone on to have four children and am currently working on my seventh book."

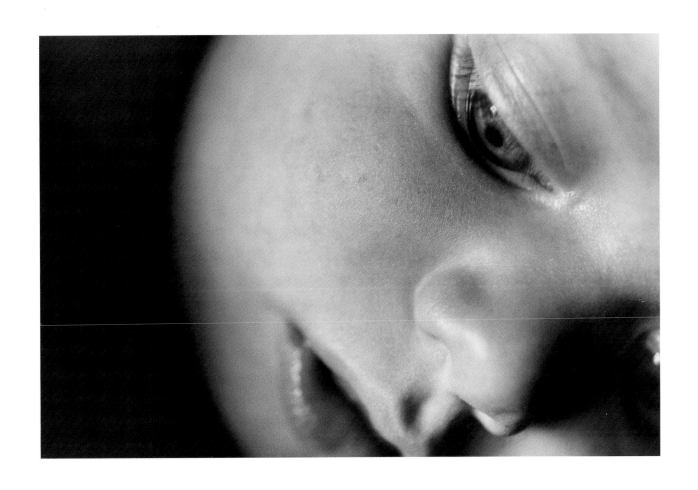

Baby in the Moon, **1981**

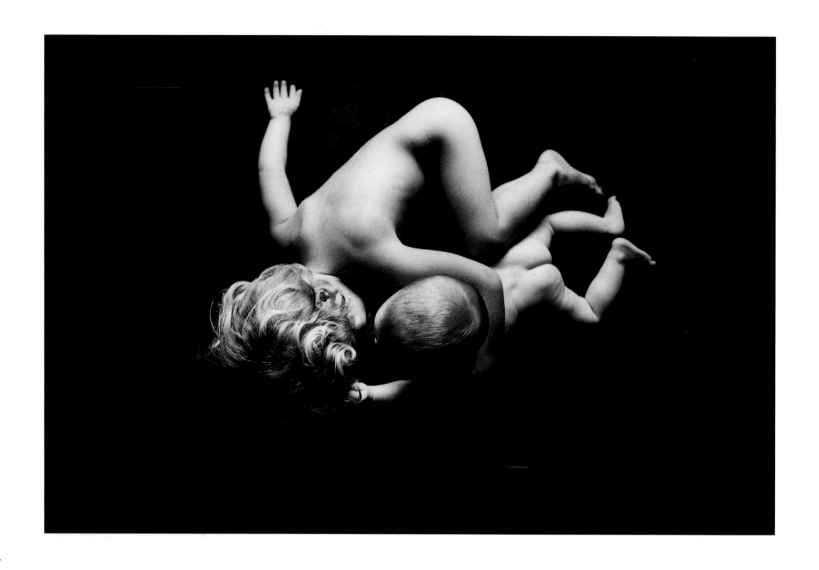

Brothers, **1981**

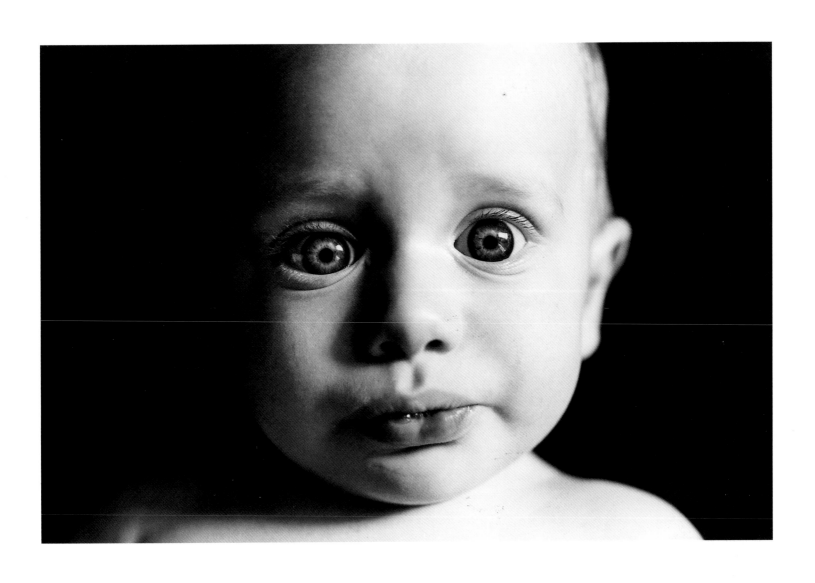

Wide-Eyed Innocence, **1981**

Graciela Iturbide

"I started to take photographs in 1969. I had three children by then whose names were Manuel, Claudia, and Mauricio. In the following year, 1970, my daughter Claudia died. Manuel and Mauricio always enjoyed seeing me with my camera. One day when he was very small, Manuel gave me a drawing that he had made which said: 'Mama, with your camera you make dreams on paper.' Later, I produced a book and entitled it Dreams on Paper.*"*

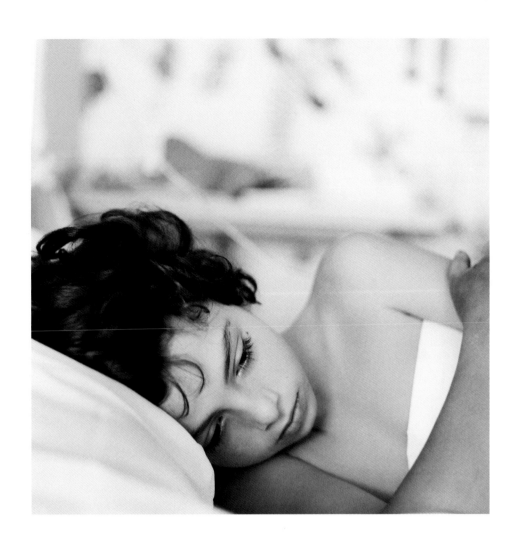

Manuel, **1973**

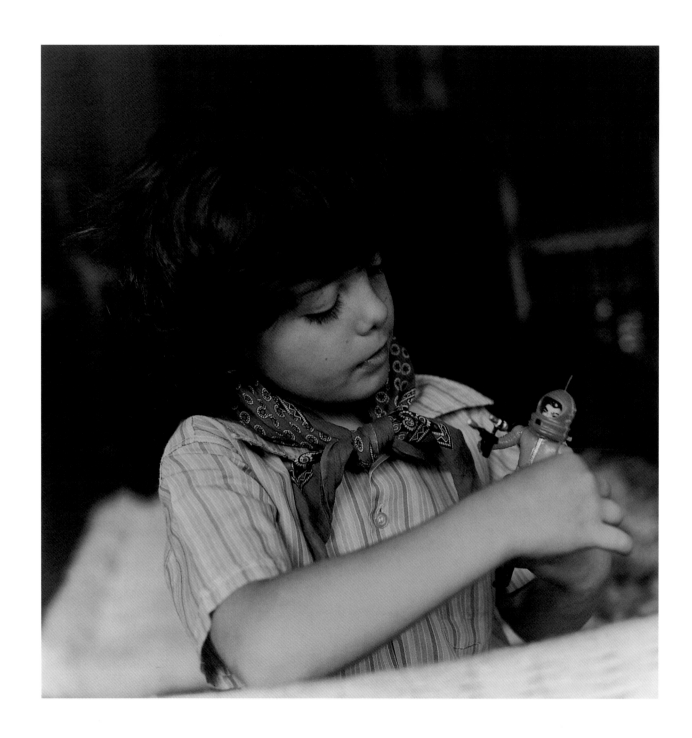

Mauricio, **1976**

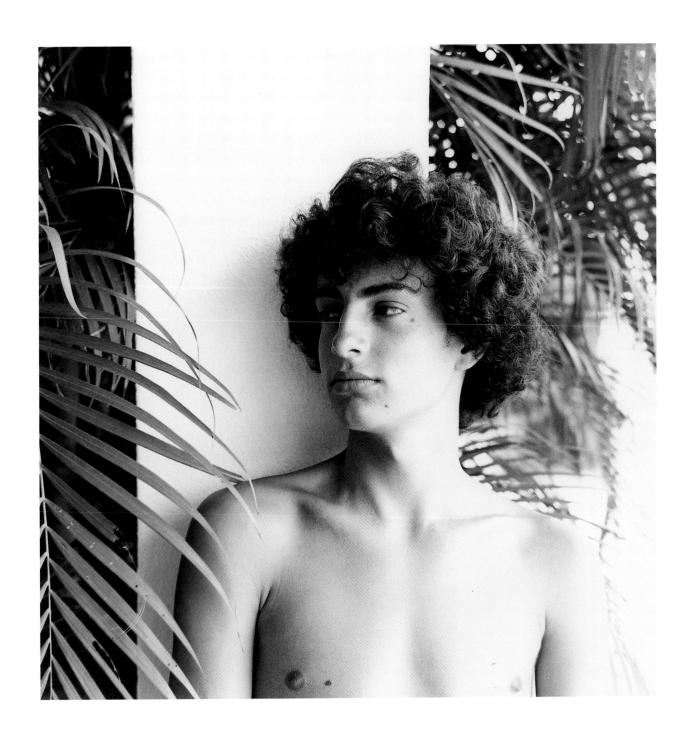

Manuel, **1980**

Margaret Sartor

"I began a series of photographs of my family when I was in my late twenties, soon after the sudden death of my father.

Like many Southerners, I was brought up with the belief that moving forward in life requires one to continually look back. Back towards home—that laser point on the horizon from which one learns to clarify the angles and shapes of any new experience. We called it "Proper Perspective." Restless and untethered without my father's defining presence, I set out to find my place in the world.

I began where I started, in the backyards and driveways of my childhood, picturing what I've known and watched since I can remember. Neighbors, sisters, uncles, and bemused and remarkably tolerant family friends entrusted themselves to me and my camera's scrutiny. When I became a parent, I began to record my own children's lives. Over the years, I have found that making photographs of those I love brings me face-to-face with what I most want to ignore—their vulnerability. Perhaps that is why I began this series. In the freefall of grief, I had to face the truth that even the deepest emotional connections are fragile. Though we may yearn for stability, we still live in a world that none of us can predict."

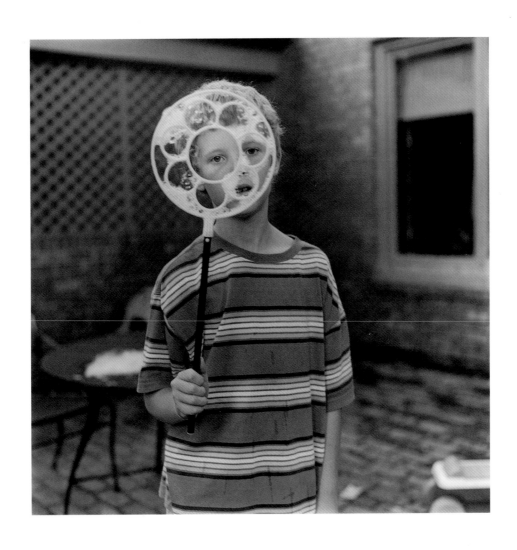

Will, Monroe, Louisiana, **1999**

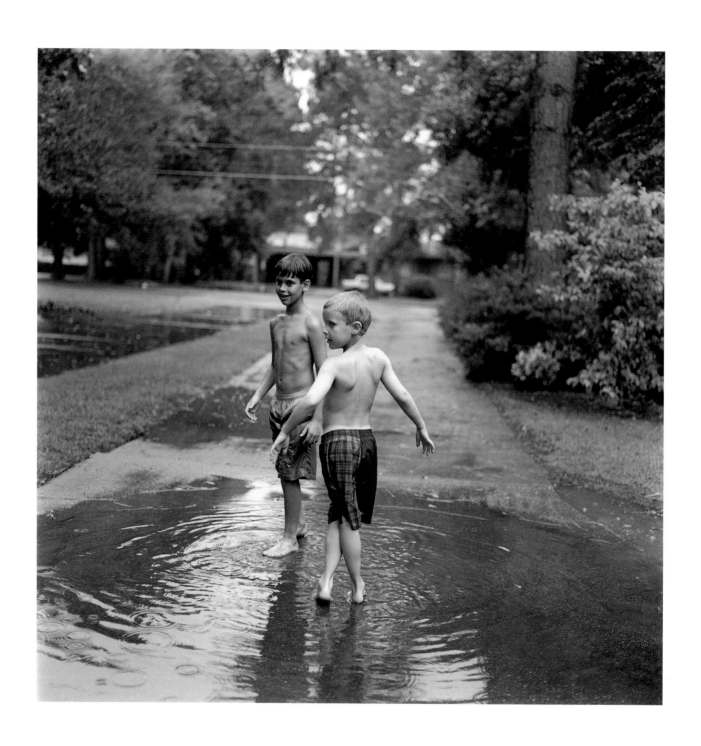

After the Rain, Monroe, Louisiana, **1997**

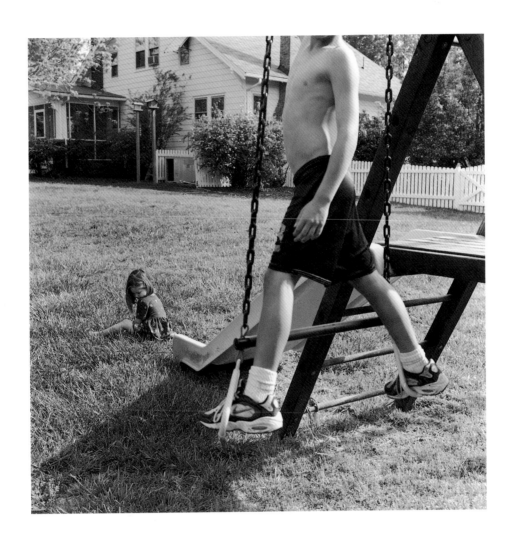

The Backyard, Durham, North Carolina, **1999**

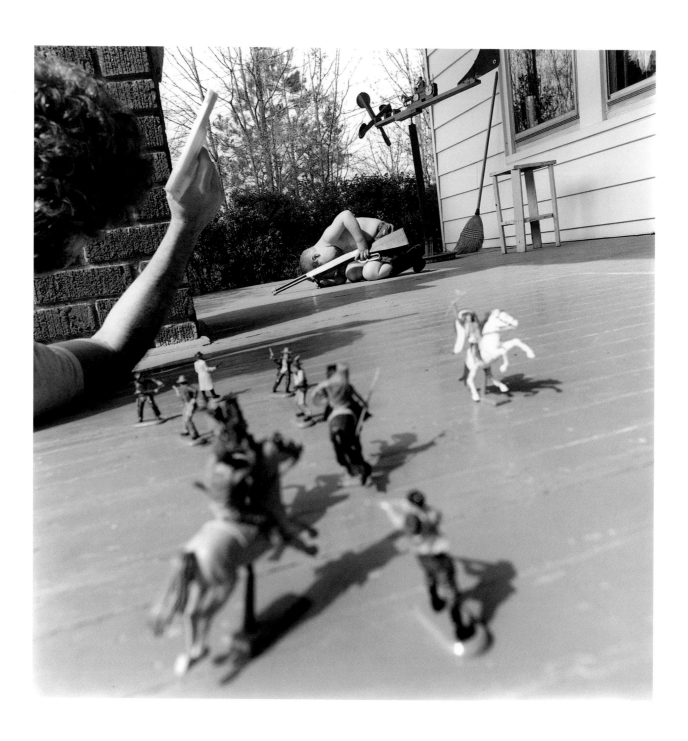

Cowboys and Indians, Durham, North Carolina, **1994**

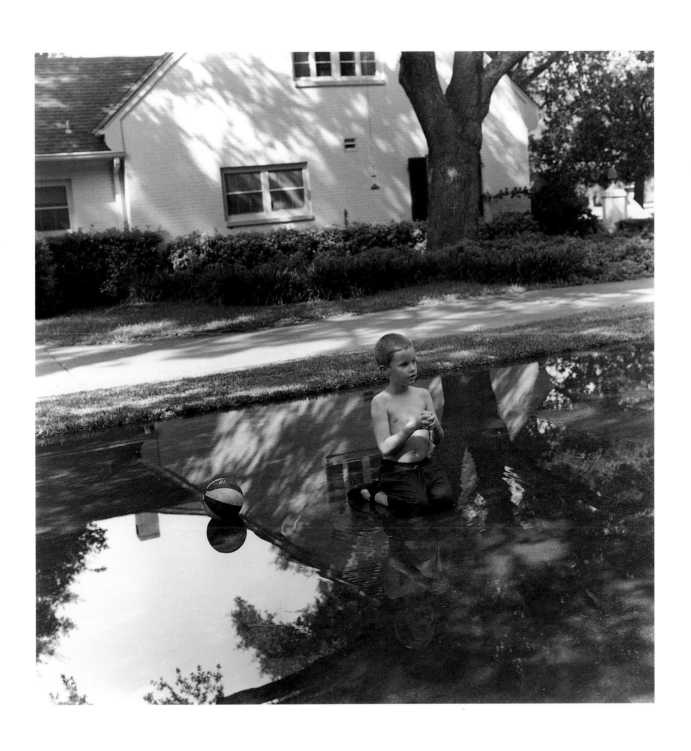

Flooded Driveway, Monroe, Louisiana, **1997**

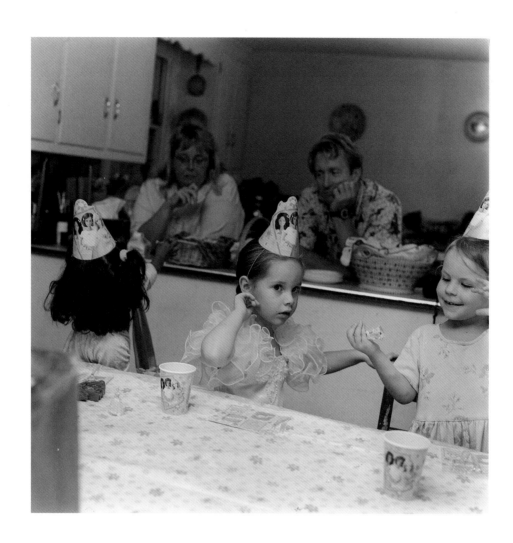

Princess Party, Creedmoor, North Carolina, **2000**

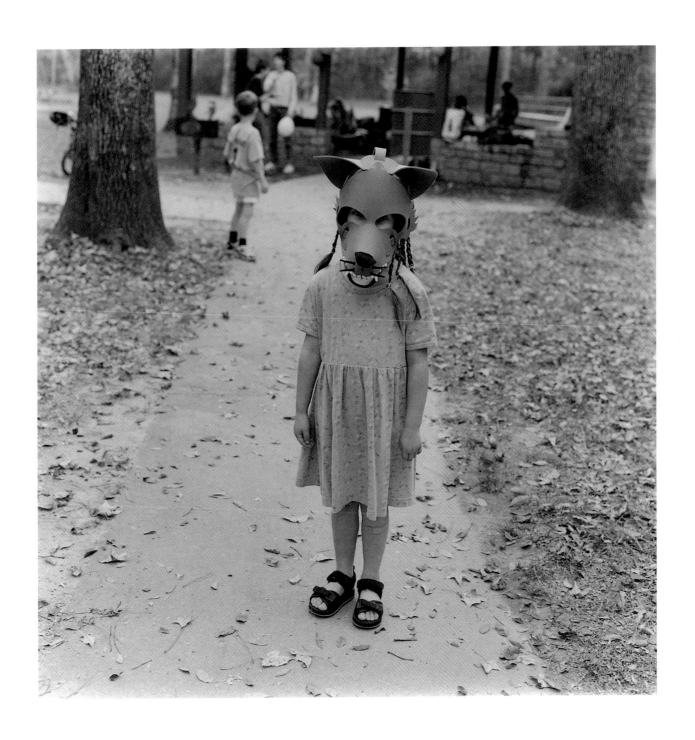

Eliza, Durham, North Carolina, **2000**

Sarah Benham

"When my daughter was growing up, she and her friends were my most available subjects. Our pool was a favorite neighborhood gathering place for them. There they were, year after year: sleek, beautiful, full of life—emerging. I was captivated."

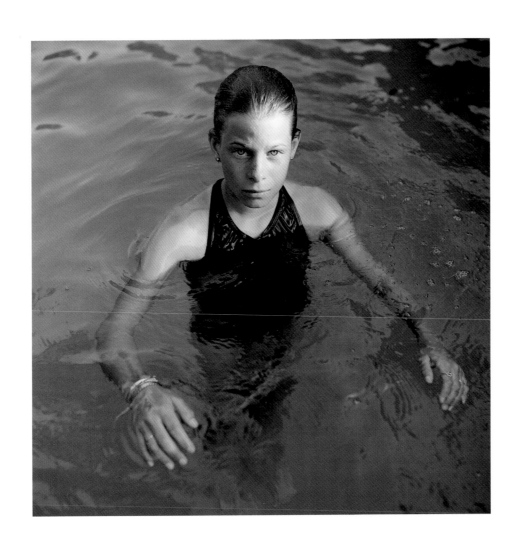

Lyerly, South Dartmouth, **1978**

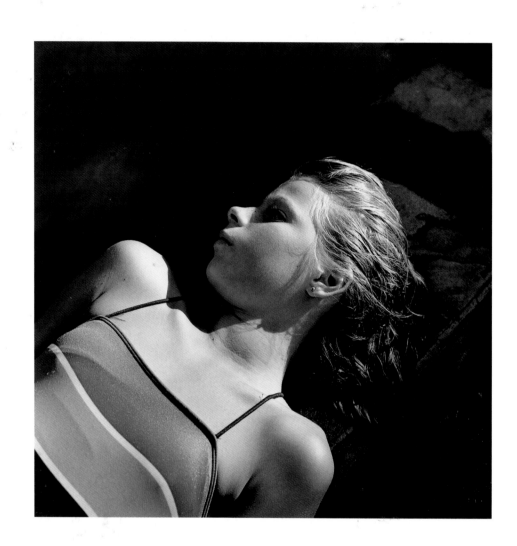

Lyerly, South Dartmouth, **1980**

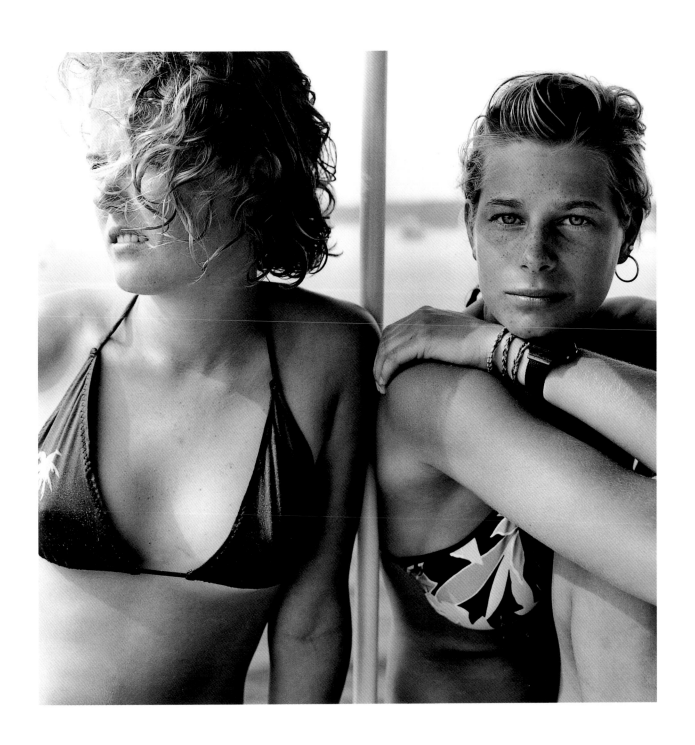

Sidney and Lyerly, Menemsha, **1986**

Tina Barney

"When I photograph my children it is for the same reasons as I photograph anyone else: because they will let me, and because I might learn something."

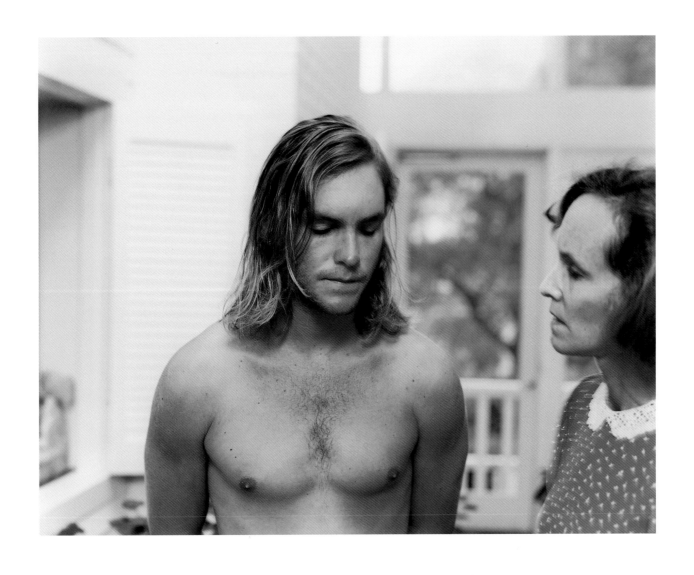

Tim and I, **1989**

Phil and I, **1989**

Donna Ferrato

"Ah, my daughter Fanny—what an enigma! Since her conception I've tried to capture her elusive nature with the camera. From when she was a cooing fetus in my belly to the days when she charmed the birds out of the trees with her sweet face, to the teenage years when she became a tempestuous siren from my deepest dreams—watching that girl grow up has been as good as breathing fresh air."

The Juggler. Self Portrait with Fanny and Philip, Paris, **1986**

Fanny and Friends, New York City, **1983**

Fanny Said: "Stop It Mom! Leave Me Alone!!", New York City, **1998**

Photographers' Biographies

Tina Barney was born in New York in 1945. She currently divides her time between Watch Hill, Rhode Island, and New York. Tina Barney was among the first artists to present her work in a large format. Her larger prints allow the viewer to virtually enter the photograph. Solo exhibitions of her work have been held at The Museum of Modern Art (1990); the Columbus Museum of Art (1999) and the Folkwang Museum, Essen (1999). In 1991, she was awarded a fellowship from the John Simon Guggenheim Memorial Foundation, and was included in The Whitney Biennial, 1987. Photographs by Tina Barney are owned by such major institutions as The Museum of Modern Art, New York, The Museum of Fine Arts, Boston, Denver Art Museum, The Houston Museum of Fine Arts, The Smithsonian Institution, Washington, DC, and Yale University Art Gallery, New Haven, Connecticut.

Sarah Benham, born in New Orleans, Louisiana, in 1941, grew up in Mississippi. She received a B.A. from the University of Mississippi in 1963. Sarah Benham began photographing in the early 1970s and has taken part in group and solo exhibitions; her photographs are featured in many private collections and also in the Fogg Art Museum, Harvard University, and the Bibliothèque Nationale, Paris. She is married, has one child, and lives in Massachusetts and Mississippi.

Niki Berg is an award-winning photographer and lecturer. Since 1982 her work has been widely exhibited, published and collected nationally and internationally. She is a recipient of the New York Foundation for the Arts Artist Fellowship Award and The Catalogue Grant, and has been a fellow at Yaddo and The MacDowell Artist Colonies. She has always been deeply engaged in portraits and family dynamics. Her most recently published works are *Sacred Connections: Stories of Adoption* and *A Gate Unfastened*, which chronicles her journey through breast cancer to recovery. Niki Berg is the mother of two grown-up daughters, Jessica and Karina, and lives in New York City with her husband Peter.

Sandi Fellman was born in Detroit, Michigan, in 1952. She attended the University of Wisconsin, Madison, where she received both B.S. and M.F.A. degrees. She lives and works in New York City, where she enjoys a successful commercial photography career along with her fine art work. Fellman's photographs are in numerous permanent collections, including the Museum of Modern Art, New York, The Metropolitan Museum of Art, New York, the Bibliothèque Nationale, The Center for Creative Photography, The Los Angeles County Museum of Art, and The Houston Museum of Fine Arts. She is currently photographing butterflies, dragonflies, beetles, and other entomological delights.

Donna Ferrato describes herself as: *"a middle-aged photographer who hungers to see everything that happens 'undercover.' Also, I am the proud mama of Fanny. Together we live (camera always loaded) south of Canal in New York City with a dark-eyed Peruvian and a black cat named Lucy. Since 1978 my camera has roamed in places where most people would rather not. My focus rarely strays from the good, the bad, and the ugly aspects of love, marriage and sex. In 1991 Aperture published my ten years body of work on domestic violence in the book* Living with the Enemy. *After the book was published I founded a non-profit-making organization called Domestic Abuse Awareness. For the last ten years we have supplied traveling exhibitions to battered-women's organizations around the world. We raise funds and awareness about the crime of violence in the home. My new book* Amore *will be published by Editions Mottas in October 2001. This book of pictures and text comes straight outta my heart of hearts. It salutes the funny, tender, sexy, healing stuff born as a result of good honest, loving relationships. In spite of the recognition I have earned for my documentation on domestic violence (the W. Eugene Smith Award, the Robert F. Kennedy Award for Humanistic Photography, a.m.o.) my greatest honor comes from being Fanny's mom. She keeps me real."*

Debbie Fleming Caffery, born in New Iberia, Louisiana, in 1948, was educated at the San Francisco Art Institute and began regularly exhibiting her photographs in the early 1980s. Her many credits include the Museum of Modern Art, New York, the 1984 Worlds Fair in New Orleans, and the Museum of Contemporary Photography in Chicago. Her work has also been shown in numerous foreign countries, among them Belgium, France, Holland, Japan, and Switzerland. Caffery was honored in 1990 when the Smithsonian Institution Press published her *Carry Me Home: Louisiana Sugar Country*, a selection of black-and-white photographs spanning nearly two decades. More recently she was

awarded the esteemed 1996 Lou Stoumen Grant by the San Diego Museum of Photographic Art on the basis of a substantial body of new photographs taken in Louisiana, Mexico, and Portugal. She currently resides in Breaux Bridge, Louisiana.

Verena von Gagern was born in Bonn, Germany, in 1946. After receiving her degree in architecture in the U.S., she turned her attention to photography, both as a freelance practitioner and as a theorist. Her daughter Franziska was born in 1970, her son Moritz in 1973. While teaching intensively at various art schools since 1975, she has also shown her work at numerous exhibitions. Her daughter Teresa was born in 1985 and her son Leonard three years later. Her book publications include: *Das einzig Wirkliche in der Fotografie ist der Zeitpunkt der Aufnahme* (Munich, 1985); *In der Glyptothek* (Munich, 1986); *Architectural* (Munich, 1993); *Der anatomische Engel* (San Francisco–Tokyo, Nazraeli Press, 1995); *Face of the Essence* (published privately, 1999).

Flor Garduño was born in Mexico City in 1957. After graduating from the Academia de San Carlos, she was hired as an assistant by the famous photographer Manuel Alvarez Bravo. Her first book of photos, *Magia del Juego Eterno*, was released in Mexico in 1985 and followed by the publication of a second book entitled *Bestiarium* in Switzerland in 1987. Her *Witnesses of Time*, a large volume of photos, was released concurrently by six different publishers in 1992. The Swiss culture journal *DU* dedicated a monograph issue to her in January 1992. The exhibition *Witnesses of Time* has been shown at forty museums thus far, among them the Art Institute of Chicago and art museums in Mexico City, Buenos Aires, and Santiago de Chile. Flor Garduño's works can be seen in numerous collections, including those of the Museum of Modern Art in New York, the J.P. Getty Museum in Los Angeles, and the Swiss Foundation for Photography. She was awarded a Swiss scholarship for Applied Art as well as grants from the Fondo Nacional para la Cultura y las Artes in Mexico. She has two children, Azul (born in 1992) and Olin (born in 1995). The photographer now lives with her family in Stabio, Switzerland and Tepoztlán, Mexico.

Esther Haase was born in Bremen, Germany, in 1966. Having completed her training in classical dance, she went on to study at the Academy of the Arts in Bremen. She then worked as a trainee in the art department of the fashion magazine *Männer Vogue* in Munich and as a photo assistant to Orion Dahlmann, Düsseldorf. Esther Haase has lived and worked as a freelance photographer in Berlin since 1993 and her daughter Marlene was born in 1994. Her corporate clients include Marlboro, Agip, Porsche, Moët & Chandon, and Nescafé. Her fashion photographs have been published in such prominent journals as *Max*, *Elle*, *Madame,* and *Stern*. Esther Haase has won a number of awards and prizes, including the Kodak Pixel Award (1997), the Reinhart-Wolf-Preis (1997–1998), and the Kodak Photo Book Award (2000) for her volume *Fashion in Motion* (Edition Stemmle, 2000).

Jill Hartley was born in Los Angeles, California, in 1950 and studied graphic arts and ethnographic film-making in Los Angeles and Chicago. She has worked as an independent photographer in New York, Paris, and Mexico City. The author of *Poland* (Editions Creaphis, Paris, 1995), *Lotería Fotográfica Mexicana* (Petra Ediciones, Mexico, 1995/2000) and the soon to be published *Le Beau Ventre/Bello Vientre*—she is currently pursuing projects in Cuba. Her daughter Lucina was born in Paris, France, in 1986.

Britta Holzapfl was born in Munich, Germany, in 1958, where she later studied Medicine and German Philology from 1977 to 1984, earning doctoral degrees in both fields. She took up photography at the age of seventeen. After the birth of her two daughters and a son, she decided to specialize in children's portraits. Her work has been widely exhibited. Britta Holzapfl was admitted to membership in the German Photographic Society in 1998. She lives with her family in Vaterstetten, Munich.

Graciela Iturbide was born in Mexico City in 1942. She studied film-making at the Universidad Nacional Autonoma de Mexico (1969–1972). In 1970 she was invited to assist photographer Manuel Alvarez Bravo, and by 1974 she had abandoned cinematography to work exclusively in photography. Her publications include *Los que viven en la arena*, a study of the Seri Indians of the coast of Sonora, *Suenos de Papel, Juchitan de las Mujeres*, for which she received the Grand Prix du Mois de la Photographie. Iturbide is the recipient of other honors as well: the W. Eugene Smith Award (1987), a Guggenheim Fellowship (1988) and the International Grand Prize, Hokkaido, Japan, among others. In 1980 she had two solo exhibitions in Mexico and began to show her work in Europe (Kunsthaus Zürich, 1981; Centre Georges Pompidou,

Paris, 1982) and in the USA (Museum of Modern Art, San Francisco). Her recent major retrospective, entitled *Images of the Spirit*, was presented first at the Philadelphia Museum of Art and then toured internationally.

Mary Motley Kalergis chronicles the bonds that connect people, families, and communities. Her documentary work has been exhibited in museums and galleries internationally, including The Smithsonian Institution, Washington, The Chrysler Museum of Art in Virginia, and the Diaframma Kodak Gallery in Milan, Italy. Her published books include *Charlottesville Portrait* (Howell Press, 2000), *Seen and Heard: Teenagers Talk About Their Lives* (Stewart Tabori, & Chang, 1998), *With This Ring: A Portrait of Marriage* (The Chrysler Museum of Art, 1997), *Home of the Brave* (E.P. Dutton, 1990), *Mother: A Collective Portrait* (E.P. Dutton, 1987) and *Giving Birth* (Harper & Row, 1983) She is currently working on a book of photographs and interviews about race relations. Photographs by Mary Motley Kalergis have appeared in newspapers and magazines around the world, including *The New York Times*, *People*, *Time Magazine*, *Glamour*, and *The Guardian* (London). She has served on the faculty of The International Center of Photography in New York and is a "special stills" photographer on movie sets. Visit her web site at www.sugarday.com.

Sally Mann was born in Lexington, Virginia, in 1951. She attended the Putney School, Bennington College and Friends World College, and received a B.A., *Summa cum laude*, from Hollins College in 1974. She was awarded an M.A. in Writing from Hollins College in 1975. She studied photography at the Praestegaard Film School, the Aegean School of Fine Arts, Apeiron, and the Ansel Adams Yosemite Workshop. She is the recipient of countless awards, including the Friends of Photography "Photographer of the Year" Award (1995), a John Simon Guggenheim Memorial Foundation Fellowship (1987), and a professional Fellowship from the Virginia Museum of Fine Arts (1982). Sally Mann's photographs are in numerous prestigious collections, including the Museum of Modern Art, the Metropolitan Museum of Art, and the Whitney Museum of American Art, to name just the ones in New York City. Her publications include *Sally Mann: Still Time*, 1994, *Immediate Family*, 1992, *At Twelve, Portraits of Young Women*, 1988, and *Second Sight, The Photographs of Sally Mann*, 1982.

Nancy Marshall, born in Marietta, Georgia, in 1946, lives in Atlanta, Georgia, and in the coastal village of McClellanville, South Carolina, with her husband photographer John McWilliams. Their daughter Katherine was born in 1981 and son Patrick was born in 1985. Nancy Marshall studied at Georgia State University in Atlanta and received her B.A. in 1974 and the M.F.A. in 1996. She has also been on the faculty of Emory University, Studio Arts Program, since 1989. She received the National Endowment for the Arts/Southern Arts Federation Photography Fellowship in 1988, and in 1982 the Nexus Press N.E.A. grant for the publication of her monograph *Ossabaw*. Nancy Marshall is currently photographing rivers and ruins of the American South.

Sheila Metzner was born in Brooklyn in 1939. She attended Pratt Institute, where she majored in Visual Communications. She was hired by the Doyle Dane Bernbach advertising agency as its first female art director, taking pictures all the while, amassing them slowly over the next thirteen years, while raising five children. One of these photographs was included in a famous and controversial exhibition at the Museum of Modern Art—*Mirrors and Windows: American Photography since 1960*—and became the dark horse hit of the exhibition. Gallery shows and commercial clients soon followed. Her unique photographic style has positioned her as a contemporary master in the worlds of fine art, fashion, portraiture, still life and landscape photography. Sheila Metzner's fine art photographs are featured in many private and museum collections—among others The Metropolitan Museum of Art, New York, The International Center of Photography, New York, the Agfa and Polaroid Collections. She has published four monographs: *Objects of Desire*, which won the Amerian Society of Magazine Photographers Ansel Adams Award for Book Photography, *Sheila Metzner's Color*, *Inherit the Earth*, and *Form and Fashion*.

Lucia Radochonska was born in Bolestraszyce, Poland, in 1948 but moved to Belgium in 1958. She studied photography at the Institut des Beaux Art St. Luc in Liège. In 1974, she married photographer Jean-Louis Vanesch and gave birth to her daughter Carole in 1983. Her works have been shown at various solo and group exhibition in Europe (Germany, Switzerland, Italy, France, Poland, the Netherlands, Belgium), Japan, Taiwan, and the U.S. since 1972.

Patricia D. Richards, single mother of three, holds a M.F.A. degree from Southern Methodist University, a M.S. in Education degree from the University of Southern California, and a B.A. degree from the University of Washington. In 1979, she accompanied her then husband on a corporate move to the South. She teaches photography in the Dallas/Fort Worth area, where she continues to make her pictures.

Margaret Sartor was born and raised in Louisiana and now lives with her husband and their two children in Durham, North Carolina. She is a photographer and editor and she is also a teacher and research associate at the Center for Documentary studies at Duke University. Sartor is the editor of *What Was True: The Photographs and Notebooks of William Gedney* as well as *Their Eyes Meeting the World: The Drawings and Painting of Children by Robert Coles*, and *Gertrude Blom: Bearing Witness* (co-edited with Alex Harris). Her photographs have appeared in *Aperture*, *DoubleTake*, *Esquire*, *Harpers* and *The New Yorker*, among other publications, and are in many private and museum collections.

Maude Schuyler Clay was born in Greenwood, Mississippi, in 1953. In 1973, she attended the Memphis Academy of Arts and was able to secure a part time job assisting the photographer William Eggleston. By 1975, she was living in New York City and working at the Light Gallery. Later, she found that all her significant photographs were being made on her trips back home to her native Mississippi Delta. When she returned to live there in the Delta region in 1987 she continued her color portrait work, for which she received the Mississippi Arts and Letters Award for Photography in 1988 and again in 1992. In 1993 she began to take black-and-white photographs of the Delta landscape. Her widely recognized monograph *Delta Land* has been published by the University Press of Misssissippi in 1999. She continues to live in the Delta with her husband and three children. Since October 1997, she has also been the Photography Editor of the literary magazin *The Oxford American*.

Annelies Štrba was born in Zug, Switzerland, in 1947, and now lives in Richterswil/Zurich. She has worked in various photo studios (including Landis & Gyr in London, 1996; Cité des Arts in Paris, 1997) and traveled extensively in Europe, Japan, and America. Her many solo and group exhibitions include shows at the Galerie Bob van Orsouw in Zurich, the Kunsthaus Zürich, the Centre National de la Photographie in Paris, the Galerie Eigen + Art in Berlin, the Metropolitan Museum of Photography in Tokyo, and the Museum of Contemporary Art in Chicago.

Joyce Tenneson, born in Boston, Massachusetts, in 1945, is the author of six books, her latest entitled *Light Warriors*, was published by Bulfinch/Little, Brown in November 2000. She is the recipient of numerous awards, including the International Center of Photography's Infinity Award for best applied photography. In addition, she was named "Photographer of the Year" by the international organization Women in Photography. A recent poll conducted by *American Photo Magazine* voted Tenneson among the ten most influential women photographers in the history of photography. Her work has been shown in over 150 exhibitions worldwide, and is housed in numerous private and museum collections. Her photographs have appeared in magazines such as: *Life*, *Time*, *Premiere*, *Esquire*, and *The New York Times Magazine*. Joyce Tenneson lives and works in New York City.

Deborah Willis, born in Philadelphia, Pennsylvania, in 1948, is Professor of Photography and Imaging at the Tisch School of the Arts, New York University. She has successfully pursued a dual professional career. First an accomplished art photographer, she later became the nation's leading historian of African-American photography and curator of African-American culture. For more than twenty years she has curated numerous exhibitions, lectured, and published the contributions of African-Americans to contemporary and historical photography. She is also a past president of the Society for Photographic Education. She has taught photography and the history of photography at New York University, the City University of New York and the Brooklyn Museum, and as the Lehman Brady Chair, in Documentary Studies and American Studies at Duke University in Durham, North Carolina. Among her most notable book projects are *Reflections in Black: A History of Black Photographers 1840 to the Present*, New York, 2000, *Visual Journey: Photography in Harlem and DC in the Thirties and Forties*, 1996, *Picturing Us: African American Identity in Photography*, 1994.

Acknowledgments

I wish to express my heartfelt gratitude to all of the photographers who took part in this project—for their spontaneous enthusiasm, for the time they invested, and for their willingness to part with photographs that are naturally very close to their hearts. The opportunity to take a closer look at their lives as photographers and mothers was a truly enriching one for me. Most of the quotations in my introductory text were taken from personal e-mails. Special thanks are due to Patricia D. Richards for her detailed and quite humorous explanations in response to my repeated incredulous questions about how one actually goes about printing photos in a car. I also wish to thank Maude Schuyler Clay for her substantial commitment to the project. It was she who put us on the track of several excellent women photographers from the southern United States who had not yet attracted international attention. I hope this book does at least something to change that.
Martina Mettner

Editorial Direction by Marion Elmer and Mirjam Ghisleni-Stemmle
Translation from the German by John Southard
Layout and Typography by Jäger & Winkler, Atelier für Kommunikationsdesign, Salem, Germany
Printed and bound by Grafiche Duegi, San Martino B.A. (Verona), Italy

ISBN 3-908163-52-8